COLORIST

A Practical Handbook for
Personal and Professional Use

Shigenobu Kobayashi

KODANSHA INTERNATIONAL
Tokyo • New York • London

CONTENTS

Translated by
Keiichi Ogata and Leza Lowitz

First published in Japanese by Kodansha as *Karaarisuto (Colorist)*.

Published by Kodansha International Ltd., 17-14 Otowa 1-chome,
Bunkyo-ku, Tokyo 112-8652, and Kodansha America, Inc.

Distributed in the United States by Kodansha America, Inc.,
575 Lexington Avenue, New York, New York 10022, and in the United
Kingdom and continental Europe by Kodansha Europe Ltd.,
95 Aldwych, London WC2B 4JF.

 3 4 5 6 7 8 9 05 04 03 02

ISBN 4-7700-2323-5

www.thejapanpage.com

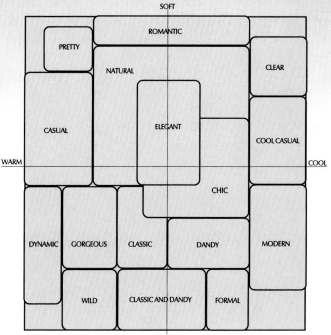

SOFT

ROMANTIC

PRETTY

NATURAL

CLEAR

CASUAL

ELEGANT

COOL CASUAL

WARM — COOL

CHIC

DYNAMIC | GORGEOUS | CLASSIC | DANDY | MODERN

WILD | CLASSIC AND DANDY | FORMAL

HARD

1 ▷ Color Research

EXERCISE 1 | Choosing Your 10 Favorite Colors

Pick 10 colors you like from the 130 colors scattered on this white ground, then choose 5 colors you dislike. Make a list of the numbers you have selected, then go to the hue and tone system on pages 8–9.

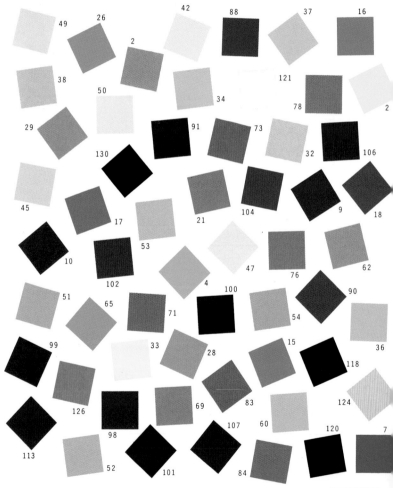

→ pages 12, 125–26

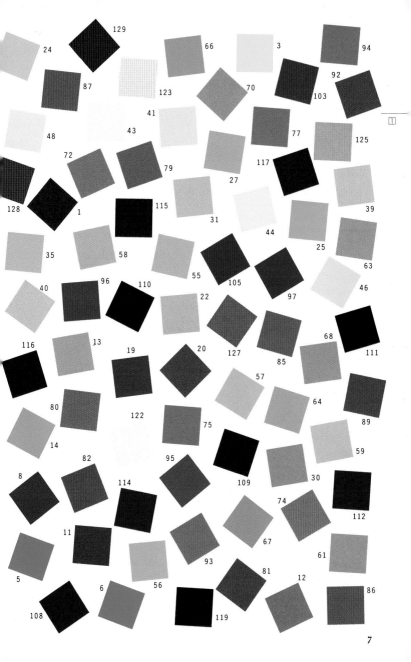

■ CHECK POINT ■
Hue and Tone System

These 120 chromatic colors are divided vertically by hue and horizontally by tone; at the far right are 10 achromatic colors for a total of 130 colors. These colors form the focus of this book. The tones range from vivid and bright to subdued and dark. Each tone is then subdivided using the 10-hued Munsell system.*

Determine your "color taste" by matching the numbers you chose on pages 6–7 with those on the chart to the right.

Are you a "hue type" who chose more hues than tones? Are you a "tone type" with a sense of brightness? Are you a "warm type" with a preference for warmer colors? Are you a "cool type" with a liking for colors in the blue group? Do you like bright calm colors, or sober grayish colors? Find your preferences.

→ pages 5,12,106,108. Refer to pages 154–55 for names of colors.

*The Munsell system was first presented in 1915 by Albert. H. Munsell, a painter and teacher of art. His system has become the standard method of classifying colors.

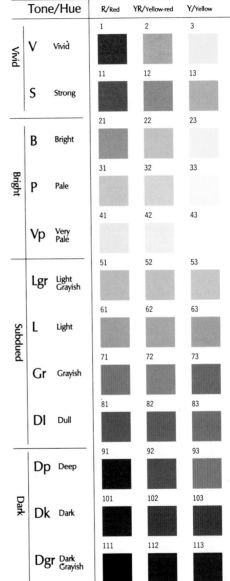

Tone/Hue		R/Red	YR/Yellow-red	Y/Yellow
Vivid	V Vivid	1	2	3
	S Strong	11	12	13
Bright	B Bright	21	22	23
	P Pale	31	32	33
	Vp Very Pale	41	42	43
Subdued	Lgr Light Grayish	51	52	53
	L Light	61	62	63
	Gr Grayish	71	72	73
	Dl Dull	81	82	83
Dark	Dp Deep	91	92	93
	Dk Dark	101	102	103
	Dgr Dark Grayish	111	112	113

GY/Green-yellow	G/Green	BG/Blue-green	B/Blue	PB/Purple-blue	P/Purple	RP/Red-purple	Neutral
4	5	6	7	8	9	10	121 N 9.5
14	15	16	17	18	19	20	122 N9
24	25	26	27	28	29	30	123 N8
34	35	36	37	38	39	40	124 N7
44	45	46	47	48	49	50	125 N6
54	55	56	57	58	59	60	126 N5
64	65	66	67	68	69	70	127 N4
74	75	76	77	78	79	80	128 N3
84	85	86	87	88	89	90	129 N2
94	95	96	97	98	99	100	130 N 1.5
104	105	106	107	108	109	110	
114	115	116	117	118	119	120	

There are 180 "image words" below. Look at them carefully and then choose 20 words you like, marking them.

Database Image Research (Taste)

1. vigorous
2. happy
3. open
4. pretty
5. tidy & neat
6. distinguished
7. friendly
8. emotional
9. bracing
10. delicate
11. diligent
12. intimate
13. colorful
14. genuine
15. merry
16. fascinating
17. mellow
18. unadorned
19. sweet & dreamy
20. clear
21. elaborate
22. cultured
23. passionate
24. speedy
25. decorative
26. cerebral
27. flamboyant
28. subtle
29. fresh & young
30. humorous
31. vivid
32. energetic
33. revolutionary
34. plain
35. comfortable & laid-back
36. active
37. chic
38. refined
39. clear-cut
40. polished
41. light
42. congenial
43. moderate
44. mild
45. rich

46. naive
47. generous
48. casual
49. lighthearted
50. jaunty
51. childlike
52. supple
53. lyrical
54. sporty
55. simple & appealing
56. exact
57. amiable
58. distinctive
59. captivating
60. vivacious
61. tasteful
62. elegant
63. dignified
64. quiet & tranquil
65. old-fashioned
66. rational
67. simple & frugal
68. sturdy
69. honest & straight-forward
70. majestic
71. forceful
72. nostalgic
73. provincial
74. earnest
75. refined & comely
76. light and pale
77. modest
78. animated
79. dignified & graceful
80. eminent
81. quaint
82. quiet & sophisticated
83. womanly
84. smart
85. bold
86. maidenly
87. restful
88. artistic & tasteful
89. metallic
90. dynamic & active

91. steady
92. mannish
93. strong & robust
94. shrewd & astute
95. spirited
96. neat
97. sober
98. manmade
99. clean
100. dynamic
101. alluring
102. free
103. feminine
104. dreamy
105. intellectual
106. cozy & comfortable
107. temperate & mild
108. brilliant
109. crystalline
110. austere
111. provocative
112. heavy & deep
113. fresh
114. extravagant
115. tough
116. urbane
117. agreeable to the touch
118. peaceful
119. tender
120. romantic
121. antique
122. gentle
123. lively
124. elaborate & delicate
125. healthy
126. nonchalant
127. sharp
128. gentlemanly
129. young
130. robust
131. pastoral
132. happy-go-lucky
133. formal
134. modern
135. masculine

136. innocent
137. jovial
138. simple, quiet & elegant
139. intense
140. noble & elegant
141. quiet
142. substantial
143. progressive
144. precise
145. manly
146. serious
147. perky
148. rich & luxurious
149. tranquil
150. wild
151. full of life
152. gentle & elegant
153. domestic
154. cute
155. sound
156. refreshing
157. fashionable
158. sacred
159. pure & simple
160. enjoyable
161. traditional
162. fiery
163. cultivated
164. vibrant
165. composed
166. lovely
167. agreeable
168. charming
169. carefree
170. luxurious
171. natural
172. pure & genuine
173. settled & at ease
174. sexy
175. dapper
176. sleek
177. showy
178. cheerful
179. graceful
180. youthful

→ pages 16, 18–19

The image words on page 10 are from a database of feelings, and have been organized below along two axes: warm/cool and soft/hard.

The scale below has also been subdivided vertically into colorful (on the left), calm (in the center) and refreshing (on the right).

Find the words you chose from the database on this scale, and consider them in light of the grouping below. Then try it on your friends, family and colleagues to compare your results.

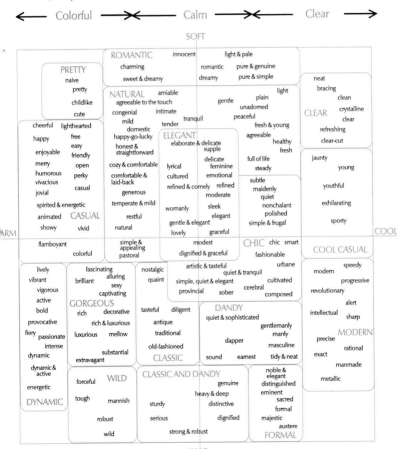

← Colorful —→ ✕ —→ Calm —→ ✕ — Clear —→

SOFT

ROMANTIC innocent · light & pale
PRETTY · charming · romantic · pure & genuine
naive · sweet & dreamy · dreamy · pure & simple
pretty · light · neat · bracing
childlike · NATURAL amiable · gentle · plain · clean
cute · agreeable to the touch · unadorned · CLEAR crystalline
congenial intimate · peaceful · clear
cheerful lighthearted · mild tranquil · fresh & young · refreshing
happy free · domestic tender · agreeable · clear-cut
enjoyable easy friendly · happy-go-lucky · ELEGANT healthy
merry open · honest & elaborate & delicate · full of life fresh · jaunty
humorous perky · straightforward supple · steady young
vivacious · cozy & comfortable lyrical delicate feminine · subtle youthful
jovial casual · comfortable & cultured emotional · maidenly
spirited & energetic · laid-back refined & comely refined · quiet exhilarating
animated CASUAL · generous moderate · nonchalant
showy vivid · temperate & mild womanly sleek · polished sporty
· restful gentle & elegant elegant · simple & frugal
flamboyant · natural lovely graceful
colorful · simple & modest CHIC chic smart COOL CASUAL
· appealing dignified & graceful fashionable
pastoral · urbane speedy
lively fascinating nostalgic artistic & tasteful modern
vibrant alluring quaint quiet & tranquil cultivated progressive
brilliant sexy simple, quiet & elegant cerebral revolutionary
vigorous captivating provincial sober composed
active GORGEOUS · alert
bold rich decorative tasteful diligent DANDY intellectual sharp
provocative rich & luxurious antique quiet & sophisticated MODERN
fiery passionate luxurious mellow traditional gentlemanly precise
intense substantial old-fashioned dapper manly rational
dynamic extravagant CLASSIC sound earnest masculine exact
dynamic & tidy & neat manmade
active forceful WILD CLASSIC AND DANDY noble & metallic
energetic tough mannish genuine elegant
DYNAMIC sturdy heavy & deep distinguished
robust serious distinctive eminent
wild strong & robust dignified sacred
formal
majestic
austere
FORMAL

HARD

© 1995 S. Kobayashi/NCD

Check the 10 colors you selected from pages 6–7 against the scale below as well. Compare how many of the favorite words you chose from pages 10–11 are in the same quadrants or areas as your selected colors. Can you discern a pattern or tendency? Is your tendency toward the soft or hard end of the chart? Warm or cool? Or is it close to the center?

This scale was created using psychological data and nuance; similar tones are linked. In terms of their color image, vivid tones, for example, suggest nuances much different than those for dark grayish tones.

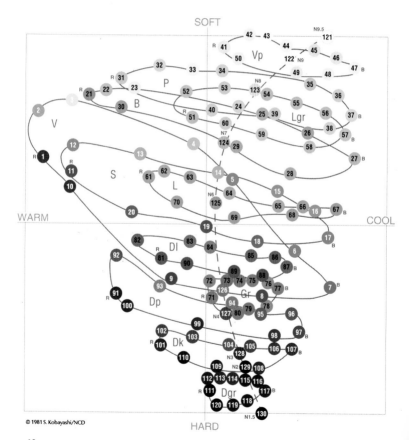

© 1981 S. Kobayashi/NCD

→ pages 112–19

Choosing 8 Color Bars

Select 8 color combinations of 5 colors and check the numbers against the chart on pages 14–15.

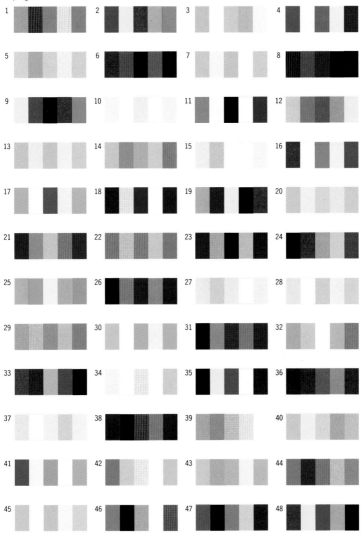

Five-Color Image Scale

The color combinations are laid out here along the warm/cool and soft/hard axes we have seen in previous pages. Note the quadrants that fit your previous selections, then locate the 5-color combinations you chose on page 13. As explained in detail in chapter 4, many techniques are used to combine colors. Check to see which technique was used to create the combinations you liked.

Technique

For your reference, the characteristic(s) of each color combination is given below. The first step of image training is to classify the color combinations on your own.

H=hue, T=tone, Si=similarity, Co=contrast, Gd=gradation, Se=separation, Cl=clear, Gr=grayish

1 T/Si	13 T/Si	25 H/Cl	37 Cl
2 H/Co	14 T/Si	26 Gr	38 Si/Gr
3 T/Si	15 T/Si	27 Cl	39 T/Gd
4 Co/Se	16 H/Co	28 Si/Cl	40 T/Si
5 T/Si	17 Co/Cl	29 T/Gr	41 Co/Cl
6 Gr	18 Co/Se	30 Cl	42 T/Si
7 H/Cl	19 Co/Se	31 Gr	43 T/Si
8 Si/Gr	20 Si/Cl	32 T/Si	44 Si/Gr
9 H	21 T/Gr	33 H	45 Cl
10 Cl	22 T/Gr	34 T/Si	46 T
11 Co/Se	23 Co/Se	35 Co/Se	47 Se
12 T/Si	24 T	36 Si	48 Co/Se

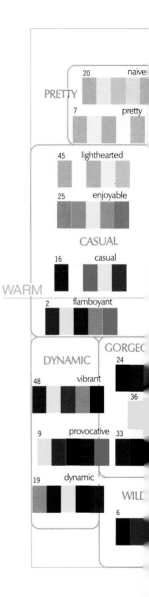

WARM

PRETTY
20 naive
7 pretty

CASUAL
45 lighthearted
25 enjoyable
16 casual
2 flamboyant

GORGE(
DYNAMIC
24
48 vibrant
36
9 provocative 33
19 dynamic
WILL
6

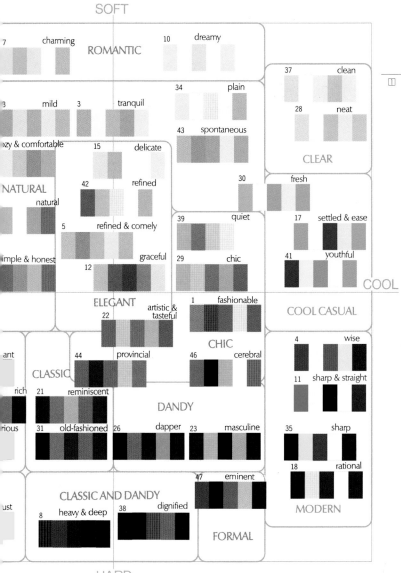

SOFT

7 charming ROMANTIC 10 dreamy

37 clean

3 mild 3 tranquil

34 plain

28 neat

43 spontaneous

CLEAR

ozy & comfortable 15 delicate

fresh

NATURAL

42 refined

30

natural

5 refined & comely

39 quiet 17 settled & ease

imple & honest

graceful 29 chic 41 youthful

12

COOL

ELEGANT artistic & tasteful 1 fashionable COOL CASUAL

22

4 wise

ant 44 provincial 46 cerebral

CHIC

CLASSIC 11 sharp & straight

rich 21 reminiscent

DANDY

rious 31 old-fashioned 26 dapper 23 masculine 35 sharp

18 rational

47 eminent

CLASSIC AND DANDY

ust 8 heavy & deep 38 dignified MODERN

FORMAL

HARD

© 1995 S. Kobayashi/NCD

15

Choose 20 words that reflect your fashion image and style of dress. If you want to match the words to those on the image scale, refer to page 156.

Database Image Research (Fashion)

1. vigorous
2. ethnic
3. mature
4. pretty
5. jaunty
6. distinguished
7. friendly
8. emotional
9. bracing
10. delicate
11. diligent
12. warm & cordial
13. colorful
14. genuine
15. soft & supple
16. warm
17. mellow
18. unadorned
19. sweet & dreamy
20. clear
21. sedate
22. cultured
23. passionate
24. speedy
25. decorative
26. cerebral
27. powerful
28. subtle
29. fresh & young
30. humorous
31. autumnal
32. energetic
33. revolutionary
34. plain
35. healthy
36. thrilling
37. chic
38. refined
39. clear-cut
40. polished
41. dramatic
42. congenial
43. pop
44. mild
45. pleasant
46. naive

47. generous
48. casual
49. lighthearted
50. smart & chic
51. quality
52. simple
53. orthodox
54. sporty
55. simple & appealing
56. exact
57. amiable
58. distinctive
59. captivating
60. loose
61. tasteful
62. elegant
63. dignified
64. quiet & tranquil
65. old-fashioned
66. rational
67. mysterious
68. sturdy
69. decent
70. majestic
71. tropical
72. noble
73. provincial
74. wild & rough
75. refined & comely
76. implausible & mysterious
77. modest
78. Oriental
79. dignified & graceful
80. eminent
81. quaint
82. quiet & sophisticated
83. womanly
84. smart
85. bold
86. fondly-remembered
87. vernal
88. artistic & tasteful
89. metallic
90. rough
91. sweet

92. masculine
93. womanly & slender
94. soft
95. spirited
96. neat
97. sober
98. manmade
99. clean
100. dynamic
101. alluring
102. radiant
103. feminine
104. dreamy
105. intellectual
106. smart & stylish
107. placid
108. radical
109. crystalline
110. gorgeous
111. practical
112. heavy & deep
113. fresh
114. extravagant
115. tough
116. urbane
117. agreeable to the touch
118. earnest
119. tender
120. romantic
121. antique
122. composed
123. jolly
124. optimistic
125. classy
126. nonchalant
127. sharp
128. gentlemanlike
129. young
130. robust
131. pastoral
132. moderate
133. formal
134. modern
135. masculine
136. mellifluous

137. docile
138. hard
139. tidy & neat
140. finicky
141. quiet
142. substantial
143. progressive
144. magnificent
145. manly
146. summery
147. wintry
148. manly
149. tranquil
150. wild
151. full of life
152. gentle & elegant
153. domestic
154. cute
155. pleasant & agreeable
156. refreshing
157. fashionable
158. avant-garde
159. pure & simple
160. enjoyable
161. traditional
162. strange
163. cultivated
164. vibrant
165. youthful
166. lovely
167. agreeable
168. charming
169. relaxed
170. luxurious
171. natural
172. transparent
173. settled & at ease
174. sexy
175. dapper
176. sleek
177. showy
178. cheerful
179. graceful
180. Japanese-style

Pick 5 color combinations for your "fashion color image."

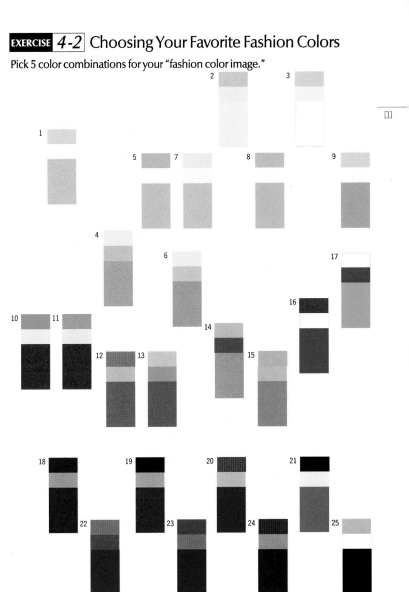

→ Refer to page 156 for each color combination's image.

Database Image Research (Interior)

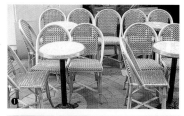

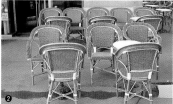

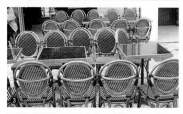

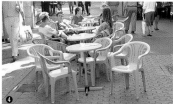

1. vigorous
2. mellifluous
3. womanly & slender
4. pretty
5. jaunty
6. distinguished
7. friendly
8. emotional
9. bracing
10. delicate
11. diligent
12. flamboyant
13. colorful
14. genuine
15. spacious
16. warm
17. mellow
18. unadorned
19. sweet & dreamy
20. clear
21. childlike
22. cultured
23. passionate
24. speedy
25. decorative
26. cerebral
27. happy-go-lucky
28. subtle
29. fresh & young
30. humorous
31. bright
32. energetic
33. revolutionary
34. plain
35. fantastic
36. finicky

37. chic
38. refined
39. clear-cut
40. polished
41. transparent
42. congenial
43. peaceful
44. mild
45. Western style
46. naive
47. generous
48. casual
49. lighthearted
50. reliable
51. simple & frugal
52. mysterious
53. organized
54. sporty
55. simple & appealing
56. exact
57. amiable
58. distinctive
59. captivating
60. rough
61. tasteful
62. elegant
63. dignified
64. quiet & tranquil
65. old-fashioned
66. rational
67. careful
68. sturdy
69. light
70. majestic
71. warm & cordial
72. unconstrained

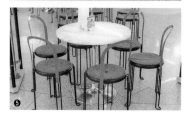

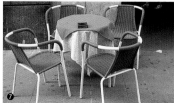

Choose 3 chairs you would like to sit on from among these café photographs.

73. provincial
74. magnificent
75. refined & comely
76. attractive
77. modest
78. temperate & mild
79. dignified & graceful
80. eminent
81. quaint
82. quiet & sophisticated
83. womanly
84. smart
85. bold
86. dramatic
87. high-touch
88. artistic & tasteful
89. metallic
90. composed
91. light & pale
92. masculine
93. open
94. elaborate & delicate
95. spirited
96. neat
97. sober
98. manmade
99. clean
100. dynamic
101. alluring
102. high-tech
103. feminine
104. dreamy
105. intellectual
106. steady
107. composed
108. slight

109. crystalline
110. gorgeous
111. dewy
112. heavy & deep
113. fresh
114. extravagant
115. tough
116. urbane
117. agreeable to the touch
118. earnest
119. tender
120. romantic
121. antique
122. ethnic
123. strong & robust
124. carefree
125. austere
126. nonchalant
127. sharp
128. gentlemanly
129. young
130. robust
131. pastoral
132. fiery
133. formal
134. modern
135. masculine
136. cozy & comfortable
137. placid
138. alert
139. tidy & neat
140. extravagant
141. quiet
142. substantial
143. progressive
144. cold

145. manly
146. tropical
147. complicated
148. explicit
149. tranquil
150. wild
151. full of life
152. gentle & elegant
153. domestic
154. cute
155. active
156. refreshing
157. fashionable
158. advanced
159. pure & simple
160. enjoyable
161. traditional
162. sensitive
163. cultivated
164. vibrant
165. youthful
166. lovely
167. agreeable
168. charming
169. comfortable & laid-back
170. luxurious
171. natural
172. simple
173. relaxed & at ease
174. sexy
175. dapper
176. sleek
177. showy
178. cheerful
179. graceful
180. Japanese style

Locations

1. Bordeaux, France
2. Marseilles, France
3. Caen, France
4. Dusseldolf, Germany
5. Vienna, Austria
6. Charleville Mezieres, France
7. Milan, Italy
8. Dusseldolf, Germany
9. Cologne, Germany
10. Marseilles, France
11. London, England
12. Milan, Italy

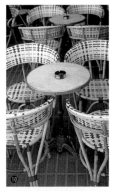

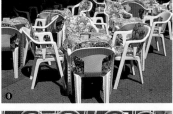

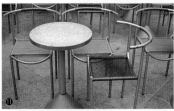

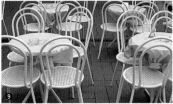

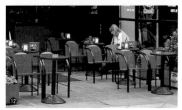

→ Refer to page 157 for each scene's location on the image scale.

19

Choose the displays you find most appealing. If it helps, pretend you are walking along an international arcade. Many charming displays can be found in the windows of retail shops. Look at the photographs carefully. Can you see how the window's image and color combination are coordinated?

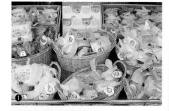

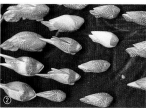

Locations
1. Kobe, Japan
2. Bangkok, Thailand
3. Lyon, France
4. Kassel, Germany
5. Lyon, France
6. Buenos Aires, Argentina
7. Tours, France
8. London, England
9. Paris, France
10. Cologne, Germany
11. Vienna, Austria
12. Milan, Italy
13. Kakunodate, Japan
14. Takayama, Japan
15. Marseilles, France
16. Paris, France
17. Seoul, Korea
18. Paris, France

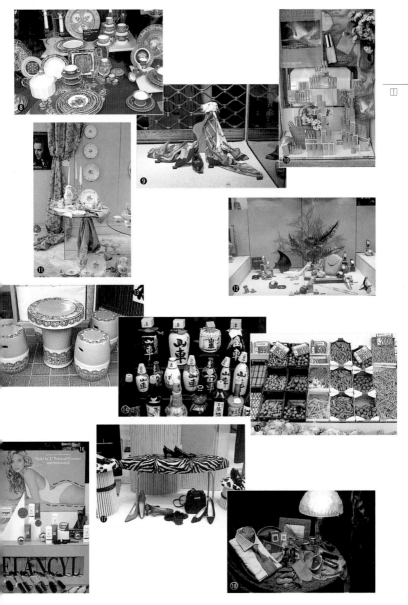

Photo Research on Streets

Building Façades and Cityscapes

Walking in the city, we can see that buildings have various faces. What kind of buildings do you prefer? Choose 4 and think about a suitable image for them. Then we'll see how that image differs according to country, even when buildings and shops are similar.

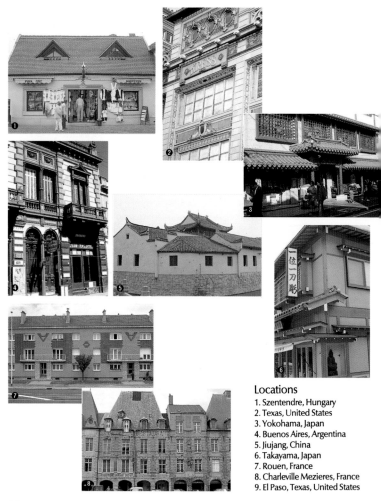

Locations
1. Szentendre, Hungary
2. Texas, United States
3. Yokohama, Japan
4. Buenos Aires, Argentina
5. Jiujang, China
6. Takayama, Japan
7. Rouen, France
8. Charleville Mezieres, France
9. El Paso, Texas, United States

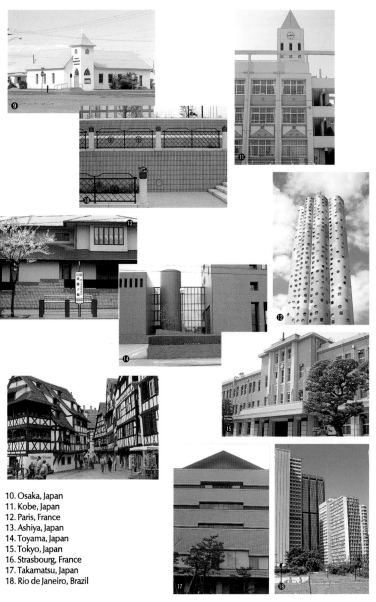

10. Osaka, Japan
11. Kobe, Japan
12. Paris, France
13. Ashiya, Japan
14. Toyama, Japan
15. Tokyo, Japan
16. Strasbourg, France
17. Takamatsu, Japan
18. Rio de Janeiro, Brazil

Images of Window Displays

Locate your choices on pages 20–21 on the word image scale below. Which kind of images made an impression? Were you attracted by soft and calm images, or hard and solid ones? Were they pleasant or sharp?

Once you understand your favorite types of goods and scenes (in addition to your favorite single colors, color combinations, and image words), your predilection concerning materials and design elements becomes clearer.

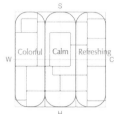

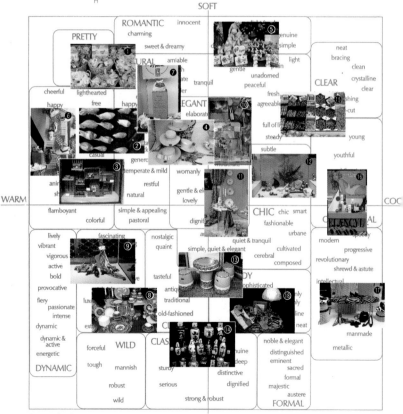

© 1995 S. Kobayashi/NCD

→ pages 11, 146

Images of Building Façades and Cityscapes

Locate the choices you made on pages 22–23. Where do they fall on the word image scale? How does their location compare with the choices you made on the facing page?

If you were ever impressed by a tourist poster, there was a behind-the-scenes image that made it memorable. If you can still recall it, try to put your impression into words and then locate that impression on the image scale. How does it compare with the other images you chose?

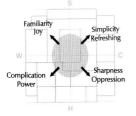

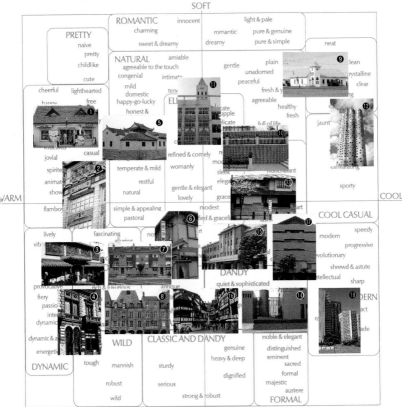

© 1995 S. Kobayashi/NCD

→ pages 145

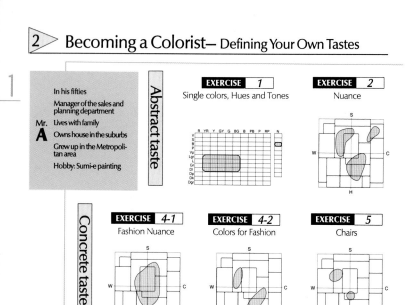

Mr. A

- In his fifties
- Manager of the sales and planning department
- Lives with family
- Owns house in the suburbs
- Grew up in the Metropolitan area
- Hobby: Sumi-e painting

Abstract taste

EXERCISE 1
Single colors, Hues and Tones

EXERCISE 2
Nuance

Concrete taste

EXERCISE 4-1
Fashion Nuance

EXERCISE 4-2
Colors for Fashion

EXERCISE 5
Chairs

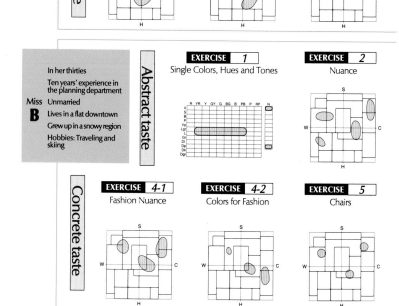

Miss B

- In her thirties
- Ten years' experience in the planning department
- Unmarried
- Lives in a flat downtown
- Grew up in a snowy region
- Hobbies: Traveling and skiing

Abstract taste

EXERCISE 1
Single Colors, Hues and Tones

EXERCISE 2
Nuance

Concrete taste

EXERCISE 4-1
Fashion Nuance

EXERCISE 4-2
Colors for Fashion

EXERCISE 5
Chairs

Check your results from pages 6–23, referring to Mr. A's and Miss B's examples.

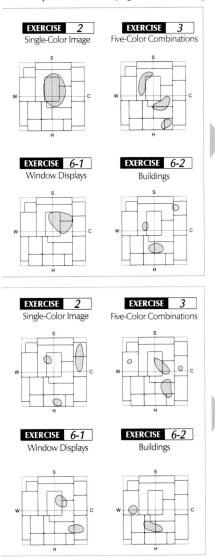

EXERCISE 2
Single-Color Image

EXERCISE 3
Five-Color Combinations

EXERCISE 6-1
Window Displays

EXERCISE 6-2
Buildings

EXERCISE 2
Single-Color Image

EXERCISE 3
Five-Color Combinations

EXERCISE 6-1
Window Displays

EXERCISE 6-2
Buildings

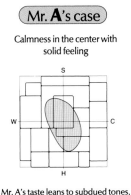

Mr. **A**'s case

Calmness in the center with
solid feeling

Mr. A's taste leans to subdued tones, like calm beige and brown. The color combination isn't one of contrast; rather, he likes a consistent tone combination. His choice of photographs also reflects his preference for calm colors.

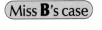

Miss **B**'s case

A bracing feeling and softness,
with calm feelings at the center

Miss B seems to have two sides: a tendency toward an active, young, refreshing taste coupled with urbane and intellectual taste. Her selected word choices are softer than Mr. A's. We can imagine that she is active not only at work but also during her private and recreational activities.

Pinpointing Taste Preferences and Color Aesthetics

There is more to being a colorist than knowing how to coordinate colors for your own use. Cataloguing your own color preferences and understanding your self-identity and taste (using the exercises on pages 6–23) is only the first step. You also need to know how to analyze the results of your research. To aid your analysis, 7 color taste profiles are shown on pages 30–31.

The basis of color research rests on selecting single colors, color combinations and word images and then using them to pinpoint taste preferences. While it may seem open-ended, you can apply these 3 basic items in many instances. And by using objects and scenes that have physical presence, a concrete direction can be determined.

The type of research required depends on the subject and people concerned. Determine what you need to know and then begin your research, taking into account the requirements and preparation expenses.

"Color" Tool

| EXERCISE | → | CHECK POINT |

Single colors →
Hue and tone system (page 8)
Single-color image scale (page 12)

5-color combinations →
Color-combination image scale (page 14)

3-color combinations →
Color-combination image scale (page 14)
→ *Color Image Scale* (page 17)

● **Hints for single-color research**

Color sample size: In order to show the difference between colors, the samples need to be the size of professional color swatches (at least 2 to 3 inches square).

How to choose: Set them down randomly and ask the testee to choose 10 favorite colors as well as 5 colors he does not like.

Tester/testee: Even an elementary school student can check his likes or dislikes or those of his family. It is also possible to test for 5 or 6 people at the same time.

● **Color combination research**

Color combination with 5 colors: Appropriate for research to determine tangible tastes, such as those concerning livelihood.

Color combination with 3 colors: Appropriate for general research to investigate color combinations and image preferences.

Make large color combination samples: Re-create the color combinations with professional color swatches.

The quantity of the samples: 20 to 30 combinations may be enough for testing if they cover all the areas of the scale.

"Word" Tool

EXERCISE → CHECK POINT

Taste→ Word image scale
(taste) (page 11)

Fashion →Word image scale
(fashion) (page 156)

Interior→ Word image scale
(interior) (page 157)

• Database image research

Basic research: Database image research is determined by cross-referencing the color combinations with the 180 words used frequently in daily life. Basically, the words do not have negative image association.

→ page 10

Research for each field: For fashion and interior research, the 120 basic words chosen from among the 180 taste research words on page 10 are combined with an additional 60 words selected for each field.

→ page 16, 18–19

What questions to ask: For "nuance research," questions can be asked about

1) favorite images,
2) actual images, and
3) future images (concerning what the subject wants to do or to be).

When following Exercise 2, it is also possible to represent a pattern of taste with as few as 15 words. Note that using objects to facilitate color research (as mentioned in the next column) is also helpful for actual color planning.

"Object" Tool

EXERCISE → CHECK POINT

Photo research
· Chairs→ Image scale (page 157)
· Window displays→ Image scale
(page 24)
· Buildings →Image scale (page 25)

[2]

• Photo research

Research with objects: Preferences can be revealed simply by using words and colors. But if the subject chooses photographs of certain objects, his or her choices can be placed on the scale to provide a hint of the subject's feelings and life vision. Their selections can also serve as visual references to determine their taste in environmental atmosphere, design and materials.

How to choose photo samples: The quality of a photograph can influence selection. The colorist's presentation to the testee must be done with care in order to obtain persuasive and objective data.

1) The quality of the photographs should be standardized.

2) Photographs used for research should cover the whole scale area.

3) The objects should be clearly photographed and have no imperfections.

Where to find photographs: Look for visual images in magazines and try to take your own photographs.

Analyzing Color Preferences— 7 Taste Profiles

CLEAR TYPE

Colorful	**Refreshing**

Colorful & Soft

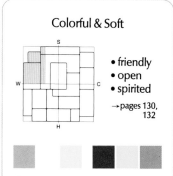

- friendly
- open
- spirited

→pages 130, 132

They selected V, B and P (vivid, bright and pale) tones. Their taste seemed basically pleasant and casual. They like contrastive combinations.

Colorful & Hard

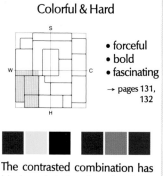

- forceful
- bold
- fascinating

→ pages 131, 132

The contrasted combination has black and dark colors that basically contain V, S and Dp tones.

Refreshing & Soft

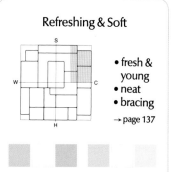

- fresh & young
- neat
- bracing

→ page 137

They like the bright tones of cool colors with G–PB hues mixed with white. They are attracted by clear-cut feelings.

Refreshing & Hard

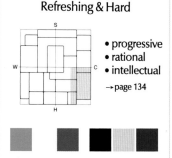

- progressive
- rational
- intellectual

→page 134

They like cool colors with BG–PB hues and achromatic colors with contrastive combinations. Cool, sharp taste.

Color preferences can be roughly divided into clear or grayish types, then into soft or hard types.

→ Refer to the detailed data of the color-sense research on pages 128.

→ Refer to the detailed data of the color-sense research on pages 128.

GRAYISH TYPE

Calm

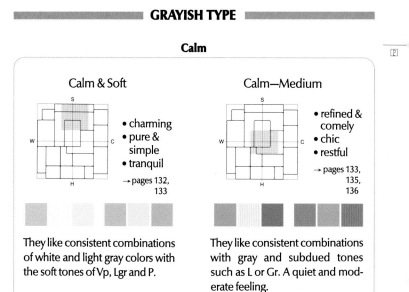

Calm & Soft

- charming
- pure & simple
- tranquil

→ pages 132, 133

They like consistent combinations of white and light gray colors with the soft tones of Vp, Lgr and P.

Calm—Medium

- refined & comely
- chic
- restful

→ pages 133, 135, 136

They like consistent combinations with gray and subdued tones such as L or Gr. A quiet and moderate feeling.

Calm & Hard

- traditional
- distinctive
- tasteful

→ page 131

They like combinations with dark colors as the main tone mixed with achromatic colors.

Variations

Some people's tastes do not fall clearly into one area but exhibit a scattered pattern. They may not be sure what they like, or they could have tastes that extend in various directions, their preferences falling into 2 of the 7 patterns here.

3 ▷ What Makes a Colorist— A Check List

▼ Ability to pick colors systematically

1. You can confirm 130 colors by hue and tone.

2. You can divide the colors around you into 10 hues.

3. You can roughly classify colors into 4 tones: vivid, bright, subdued and dark.

4. You can divide these further into 12 tones.

5. You can recognize the 10 achromatic colors. → chapter 1

▼ Ability to judge color using color charts

1. You can distinguish subtle color differences using color charts, which are the basis of the standard.

2. You can subdivide the colors around you into 40 hues and 12 tones.

3. You can assess the colors used in fashion and interior design, and put this data to use for each season. → chapters 1 to 3

▼ Ability to place colors with their color images

1. You can recognize each of the 130 color characters as warm/cool and soft/hard.

2. You can judge single colors as clear/grayish.

3. You can divide color combinations of 2 and 3 colors into warm/cool and soft/hard.

4. You can divide various color combinations into similar (homogeneous) or different (heterogeneous) images.

5. You can express images as words by looking at single colors and color combinations. → chapters 3 & 4

▼ Ability to master color combination techniques

1. You can represent the things around you with color combination samples within the 130 basic colors.

2. You can accurately indicate the color combination techniques used in fashion, interior and signs.

3. You can use suitable color combination techniques with images you pick.
 → chapter 4

▼ Ability to classify images

1. You can roughly group objects around you as colorful, calm and refreshing.

2. You can divide the images of objects into warm/cool and soft/hard and recognize the meaning of each image.

3. You can coordinate various items used in daily life with compatible images.
 → chapter 5

▼ Ability to perform color research

1. You can effectively combine taste research of single colors, color combinations and word images with environmental research and photo research on site, then transform this information into data to judge the results.

2. You can take photographs to show color images . → chapters 1, 4 & 5

2 Developing a Sense of Regional Colors

① Matsue A restaurant signboard (RP)
② Onomichi A town by the ocean (B–PB)
③ Kurashiki Rush mats, a local product (GY–G)
④ Matsuyama A place of oranges (YR)

1 > Discover Regional Colors

Regional colors are often widely unacknowledged locally, even though they have been handed down for generations and used almost instinctively. The observant colorist, however, will soon discover the colors which reveal a region's identity.

If you review photographs of scenes that attracted you while traveling, you will most likely notice the colors that predominate in the region. Why are they there? Because people have been creating comfortable and beautiful color combinations and images to fit their own shared needs and desires for years. They have developed a sophisticated sense of color coordination, particularly for local color preferences. Consequently, discovery and use of regional color is a reasonable way to record an area's characteristics and distill its essence.

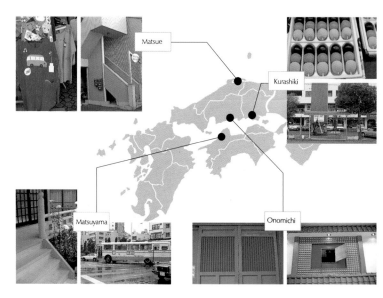

In northern climes, reds often surface on building façades in order to create a feeling of warmth in winter.

1. Glasgow, Scotland—The red and deep-toned exteriors are appealing and have a profound depth.
2. Caen, France—The red flowers echo the red of the streetlamps and add an attractive touch of warmth in this northern port town.
3. Nagano, Japan—Red draws the eye at Zen-koji Temple.
4. Goshogawara, Japan—The subdued tones of walls and garden create a nice back-drop for powerful murals of traditional festivals.
5. Orleans, France—The heraldic emblems in red, white and black appear to be in motion in the city made famous by Joan of Arc.
6. London, England—Deep red is an attractive complement to the brick streets. The red of the city's double-decker buses is world famous.

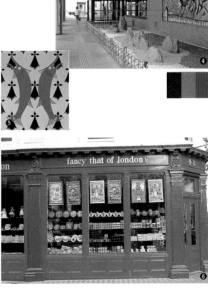

→ Some other cities with R hues—Lille, Toulouse (France); Gottingen, Mainz (Germany); Linz, Salzburg (Austria); Sapporo, Yamagata, Mito, Tokamachi, Naha (Japan).

2

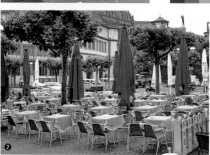

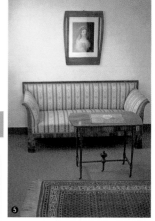

R-type colors from dark red to brick red to brown are basic colors in northern countries.

1. Gottingen, Germany—An academic town with folkloric roots. It also has a profound, classical atmosphere.

2. Frankfurt, Germany—A town born of commerce, with its color combinations of red tones that animate scenes for travelers.

3. Caen, France—A mound of earth at a construction site with reddish hues denotes a clear basis for local color preferences.

4. Asahikawa, Japan—This northern town is very cold in winter. The school wall conveys a warm image with its brick color.

5. Baden, Austria—Near Vienna, this town, a well-known tourist haunt, is surrounded by forest. This room's interior focuses on a calm red/brown tone combination.

→ Some other cities with R/YR hues: Strasbourg (France); Tono, Sendai, Fukushima, Aizu Wakamatsu, Koriyama, Toyama, Kanazawa, Nara, Takamatsu, Nagasaki, Kagoshima (Japan).

YR brown is calmer than red-brown. It is the color of such natural construction materials as soil, bricks and timber and has become a basic color in each place pictured here.

1. Amiens, France—There are several R–YR-type walls here. The town also has a cathedral which underscores its history.
2. Aizu Wakamatsu, Japan—Brick buildings still stand in this town, rich in history. The effective tonal contrasts look quite beautiful.
3. Lyon, France—This town has a tradition of silk-textile manufacturing. The station combines modernity with sensitivity.
4. Seoul, Korea—The delicate rhythm of the columns, the windows, the gray roof tiles and the brown walls conveys a presence of mind.
5. Takamatsu, Japan—The YR-type packages used by Japanese confectioneries capture the atmosphere of the region's taste and create a sense of nostalgia.

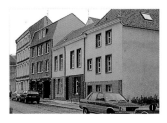

6. Takayama, Japan—These wooden display stands create a feeling of calm. Even the ticket wickets at the rail station are decorated to highlight local products.

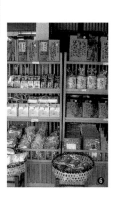

→ Refer to page 148 for a color chart used frequently for interior design.

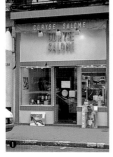

→ Some other cities with YR hues: York (England); Leipzig, Stuttgart (Germany); Strasbourg, Le Havre (France); Tottori, Matsuzaki (Japan).

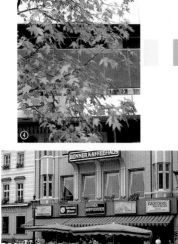

Citrus fruits, nuts, berries, bark, soil and the color of bread—items with their beige, brown and bitter orange colors—have YR-type hues and offer us the fundamental colors of life.

1. Amiens, France—A soft apricot color and gray tone form a delicate combination.
2. Vienna, Austria—The dark chocolate in this color grouping emphasizes the central European tradition with its exalted style.
3. Matsuyama, Japan—This town has taken orange to heart. The color can be found on streetcars, buses and even on public ashcans.
4. Gifu, Japan—The textile distributor's street is paved in brown tones, and the brown of the trees, reflected in the glass of the distributor's stylish building, reinforces the earthy sense of the area.
5. Bonn, Germany—In this bright yet subdued setting, concerts can be heard on Sundays. And the café, with its cheerful yellow, is refreshing and inviting.

Yellow is a symbol of sunlight. In Chinese history, shining yellow is the color of the son of heaven. It is also the color of gold and harvest and suggests richness.

1. Budapest, Hungary—A combination of yellow and YR-type brown gives a sense of amenity and lightness.

2. Suzhou, China—Suzhou is famous in Chinese poetry. For the Chinese, yellow is a noble color.

3. Leipzig, Germany—A yellow-striped awning lends cheer on the streets of this often cloudy town.

4. Takamatsu, Japan—YR and Y are well combined in this oceanside town. Pine tree greens and brown are prominent in the region.

5. Matsuyama, Japan—The yellow and bitter orange found on the streets are also used in displays for a restrained flamboyance.

→ Some other cities with Y hues: Beijing (China); Bangkok (Thailand); Liverpool, Bath (England); Bremen, Berlin, Potsdam, Dusseldorf, Cologne, Aachen, Bonn, Munich (Germany); Strasbourg, Nancy (France); Kecskemet, Pecs (Hungary); Akita, Himeji, Wakayama, Tokushima, Oita, Miyazaki (Japan).

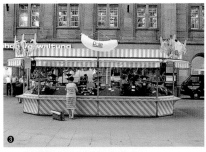

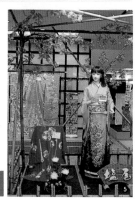

2

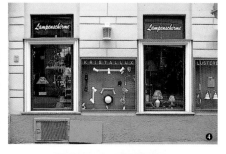

When yellow becomes light and soft, a feeling of elegance emerges, an image used for building façades seeking sophistication.

1. Luneburg, Germany—A delivery truck is colored in different tones of vivid yellows.
2. Charleville Mezieres, France—A place where French sensibilities meet German. The soft yellow provides its own character.
3. Takayama, Japan—The dark brown bark colors come into focus strongly and sharply with the soft and yellow wall.
4. Graz, Austria—This town has many buildings in calm gray. The soft yellow denotes retail stores and harmonizes nicely with GY tones.
5. Hannover, Germany—The yellow canopy and the light gray of the wall the are coordinated with the similar grayish tone of the interior displays. Amber aiso works well here.

Regional colors are not necessarily aligned with a single color. They frequently emerge as a combination of red and brown, orange and yellow, yellow and green, brown and blue, and white and black.

1. Budapest, Hungary—In a city of many bridges, the strong image of the huge steel structure is countered by a natural light green.
2. Graz, Austria—Many buildings, particularly those engaged in retail business, are dressed in calm green.
3. Nara, Japan—The color for the bank's image was selected from the colors that local people enjoy.
4. Linz, Austria—Cool green appears on the streetcars here, supposedly a nod to the well-known forest nearby.
5. Pecs, Hungary—Cool greens and yellows stand out in this historical and academic town. The design here has a clear tonal combination.

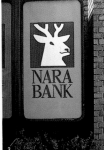

NARA BANK

GYORSNYOMTATÓ

FÉNYMÁSOLÁS AZONNAL!

NÉVJEGYEK,
LEVÉLPAPIROK, ÉRTESÍTÉSEK,
BORÍTÉKOK, MEGHÍVÓK,
ÖNTAPADÓS MATRICÁK,
SZÓRÓLAPOK,
BÉLYEGZŐK KÉSZÍTÉSE.

A KÖNYVESBOLTBAN

NYITVA:

SCHOPFKOTELETT

→ Some other cities with GY and G hues: York (England); Bonn (Germany); Asahikawa, Akita, Shiobara, Maizuru, Kyoto (Japan).

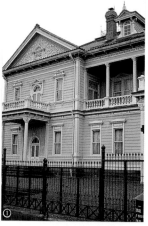

B can be found in areas near the ocean. If a forest is nearby, this may become G. BG has taken root along northern ocean and lake regions. PB is normally used in Japan, but B is prominent in Western countries.

1. Hakodate, Japan—The Western-style buildings in sky blue here are impressive.
2. Marseilles, France—The clean turquoise blue is combined with white for a clear and refreshing southern French color.
3. Iwaki, Japan—The full range of blue from B to PB is used in this fishing port town.
4. Hiroshima, Japan—Clean blue-green is used for telephone booths in this river town.
5. Bremerhaven, Germany—The blue of the sea used here has a refreshing, sporty sense.

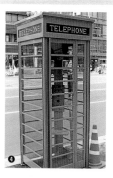

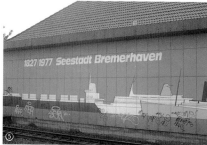

→ Some other cities with blue (B and PB) hues: Kiel, Hamburg (Germany); Le Havre, Vannes, Nantes (France); Otaru, Niigata, Kanazawa, Toyama, Mito, Oiso, Shingu, Tokushima, Saga, Oita, Nagasaki (Japan).

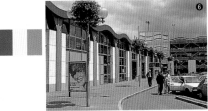

Navy colors are boating and oceanic tones. In many regions, indigo dyeing brought this color into daily life long ago.

1. Hamamatsu, Japan—Silver, blue and achromatic colors supply a cool image.
2. Marseilles, France—PB is used for canopies to liven up older buildings.
3. Aomori, Japan—A blue design can be found under the trees, an attractive touch in this northern port town.
4. Daikanyama, Japan—Casual yet cool defines this scene in a section of Tokyo.
5. Yokohama, Japan—A popular pedestrian walkway is rhythmically coordinated in a style which recalls the lively history of this port town.
6. Nancy, France—This riverfront town chose blue for its station building, adding a calm, mature sense to the modern image.

2

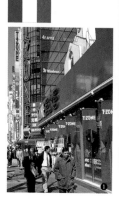

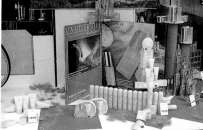

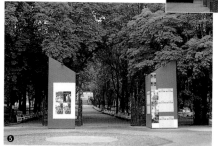

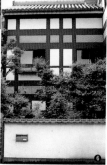

Purple and red-purple are not regional colors. However, as a culture matures, these colors begin to emerge, particularly in larger cities.

1. Akihabara, Japan—The artificial and detailed images supposedly reflect young people's tastes.
2 & 3. Cologne, Germany—The town's atmosphere of richness fits the elegance of this display and streetcar.
4. Bremen, Germany—The refinement of the banner's color suggests this is a spot for music.
5. Baden, Austria—Purple signs emerging from a green ground announce cultural activities.
6. Sasayama, Japan—A splash of elegant red-purple is used on a traditional restaurant in this small town near Kyoto.

White Infinite and Almighty White

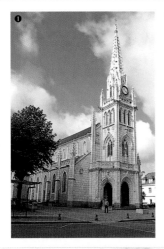

White is clear and emphasizes other colors. Everyone has a tendency to respect white. Examples of off-white are also shown on this page.

1. Lorient, France—A small and romantic town in Bretagne Province. The church has a white and noble atmosphere.
2. Kochi, Japan—The white here lends this girls' school a clean and tidy image. Throughout the whole town white is used as the basic color.
3. Iida, Japan—They love white, suggestive of mountain snow.
4. Singapore—Buildings in white and off-white offer cool images to people living in hot climates.
5. Windermere, England—The traditional homes by the lake seem to maintain the Celtic culture.

→ Some other cities with white: Bangkok (Thailand); Wiesbaden (Germany); Saku (Japan).

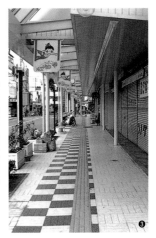

Gray Chic Natural and Artificial Colors

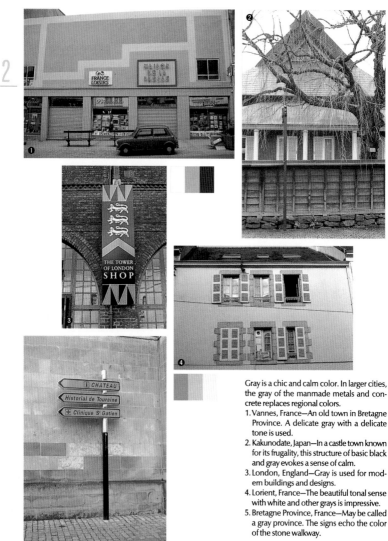

Gray is a chic and calm color. In larger cities, the gray of the manmade metals and concrete replaces regional colors.

1. Vannes, France—An old town in Bretagne Province. A delicate gray with a delicate tone is used.
2. Kakunodate, Japan—In a castle town known for its frugality, this structure of basic black and gray evokes a sense of calm.
3. London, England—Gray is used for modern buildings and designs.
4. Lorient, France—The beautiful tonal sense with white and other grays is impressive.
5. Bretagne Province, France—May be called a gray province. The signs echo the color of the stone walkway.

→ Some other cities with gray: Berlin, Hamburg (Germany); Bordeaux (France); Morioka, Kawagoe, Tokyo (Japan).

Black Black—A Color of Tradition and Chic

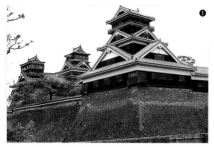

Black is an imposing color. It also has a dandy and robust side. As a samurai color, it appeals to a kind of clean solemnity, as does white.

1. Kumamoto, Japan—The black-and-white combination here gives this warrior's castle a manly, stately and protective image.
2. Stratford-upon-Avon, England—Shakespeare's town. The black signs are stern and heavy.
3. Edinburgh, Scotland—The black façade apparently signifies gentlemanly behavior.
4. Edinburgh, Scotland—The same black used in the Kumamoto castle can be seen here.
5. Morioka, Japan—The sharp delineation of black and white on the wall of this Japanese-style restaurant is at once traditional and chic.
6. Chester, England—The cheerful and beautiful rhythm of black and white is the traditional style of this area.

▼ The Meaning of "Regional Color"

Even though we may recognize different regional cuisines or customs, we often fail to take into account the importance of the local colors that characterize a particular area. This is because the colors have an intrinsic quality: essential yet as inconspicuous as the air we breathe.

It is difficult to subjectively identify regional colors. However, in researching colors of four historical seaside towns in western Japan, we found the following characteristics:

Matsue has Korean red → Hues R, RP, P
Matsuyama has orange → Hues R, YR, Y
Kurashiki has green corollary
 → Hues GY, G, BG
Onomichi has blue/navy corollary
 → Hues B, PB

The more a culture matures, the more the colors and images of food products, clothing and shelter take on new and greater meaning. In the twenty-first century, determining regional colors and designing cities and products using color and image should be viewed as one of the professional colorist's most important jobs.

▼ Researching Regional Colors

The methods other forms of field research take include:

1. Taking photographs of an area

• Take slides with a single-lens reflex camera.
• The locations can be commercial, business or residential areas; parks, streets or natural landscapes. The subjects are limitless and may include buildings, houses, stations, squares, public places, shops, signs, exhibits, benches, lanterns, road surfaces, trees, street furniture, clothes, posters, everyday objects, cars, taxis, buses, trains, the ground, water, grass and flowers.
• The time for research should be between 9 a.m. to 4 p.m.
• For cities of more than 40,000 people, 10 rolls of 36 exposure film will be needed. For cities of less than 40,000, approximately 6 rolls will suffice.

2. Judging and sampling colors

• One area should be researched twice—in summer and winter.
• The characteristic colors need to be roughly located on the color chart. Detailed research may require further comparisons with the color chart.
• The details may need to be checked, depending on your needs, against varying weather conditions.

3. Discovering regional colors

• Executing preliminary research: It is not necessary to restrict your search to a single color, but preliminary research is needed in advance to compare key colors and multiple secondary colors.
• Selecting a single color to identify the landscape: A group of 200 to 500 slides taken in each city becomes your image database and offers a general view of each city. Run your selection of a representative scenes by 5 or 6 people. If they are in agreement, then the selected image is probably a recognizable regional color.

Travel is the ideal way to sharpen your image sense. By comparing the colors of the places you visit with your hometown's colors, you can expand your understanding.

▼ How to Apply Regional Color

The photographs on pages 33–34 are representative scenes of regional areas. In Matsue, I found related reds on billboards, bridges, lampposts and walkways, and similar RP hues on potted flowers. During my trip to Kurashiki, I noticed schoolboys in green sportswear, and the green of rush mats, a local product. The green bus stops seem to blend well with the landscape. When I visited Matsuyama, I saw orange in the window displays, on clothing and on small articles in shops. In Onomichi, which faces the ocean, blue was used for billboards, the front shutters of retail stores, house roofs, and as accents for many other structures.

The role of regional colors is vital and varies with usage. Here are a few guidelines to applying them in various situations:

1. For living—they are the basis of the area's image and help instill a sense of pride. Using these colors suggestively brings convenience into daily life.

2. For groups—they encourage study and work, and facilitate cooperation in schools or offices.

3. For tourism—key colors indicate an area's attractive points to tourists.

4. For history and tradition—colors are always linked to the culture. They reinforce the behavior, products and aesthetics that have developed with the area.

5. For landscape—the sensitivity of home is integrated with the landscape and instills a sense of community.

6. For architecture—colors are considered in the construction and the general aesthetic sense of the town, and are also a useful tool for local industries and marketing.

2 ▷ Color Combination Techniques

Technique ❖ Hue/Color Combination

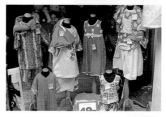

Multi-hued settings of various color combinations are effective in designing a vital, appealing atmosphere. Peppers set out on colored plates—a vivid Bangkok palette—make it easy to imagine a spicy Asian meal. Children's clothing in pink, yellow and blue-green is charmingly displayed in Gottingen. Buildings in old-town Innsbruck seem to wear their hues of R, Y and G quite naturally.

→ Other references: pages 39 (5), 44 (1)

Technique ❖ Tone/Color Combination

1. Bangkok, Thailand
2. Gottingen, Germany
3. Innsbruck, Austria
4. Vienna, Austria
5. Paris, France
6. London, England

Keeping to two hues and using color gradation or tonal effects effectively means using a "tone/color combination." The window display in Vienna romantically coordinates salmon-pink and clear white. In Paris, a hotel façade combines light gray, a slightly darker beige with a grayish base, and contrasting black accents for a chic look. In London, the vivid black and white posters are set against the gray pavement and dark brown façades, and even we seem aware of their dandyism.

→ pages 36 (2, 5), 37 (2, 3), 38 (1, 2), 40 (2, 4), 41 (5), 42 (2, 5), 43 (1), 46 (1, 2, 3)

→ pages 112-13

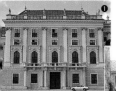

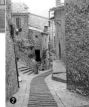

1. Vienna, Austria
2. Assisi, Italy
3. Geneva, Switzerland
4. Linz, Austria
5. Hamburg, Germany
6. Geneva, Switzerland

Technique ❖ Similarity (Grayish Colors)

As grayish colors do not clash, it is easy to combine them. A successful combination will manifest calmness. On European streets, the grayish colors of natural stone form a color base for the environment. A delicate tonal sense using Y shades adds an elegance to the façades of some of Vienna's buildings. We can sense a quiet feeling in a small alley in Assisi, where a medieval atmosphere still prevails. A leather crafts display in Geneva relies on a similar tonal effect.

→ pages 35 (1, 4), 39 (1), 41 (2), 43 (1), 44 (2), 45 (3, 4), 46 (1, 5), 47 (3). Grayish colors: pages 35 (6), 40 (2), 41 (5)

Technique ❖ Contrast (Clear Colors)

A vivid, fresh color combination that successfully employs contrast easily attracts our attention. Ripe tomatoes placed in blue boxes make for a clear yet vibrant look. In a shop window of cool tones, blue tableware, silver and glasses are brought to life with the simple addition of a yellow napkin, an especially effective accent. The reds and yellows of a café enliven a grayish street scene and underscore the flamboyant prosperity of Geneva.

→ pages 35 (3, 5), 36 (2), 47 (1, 2, 4); Clear colors: pages 39 (5), 42 (2)

→ pages 114-15 ,118-19

Technique ❖ Separation

Separation is a technique used for creating contrast. Gradation is the key to creating a subtle effect. Placing green apples between warm-colored fruit makes them all look delicious. The bold bars of red and white on flags arranged rhythmically brings a building façade vividly into view. Dark brown frames around showcase windows emphasize the display area, which can be seen clearly from a distance. Though the effect does not guarantee people will step up to the display windows, the clever color usage draws initial interest.

→ pages 36 (1, 2), 40 (3), 42 (1, 2), 44 (6), 45 (2), 47 (5, 6)

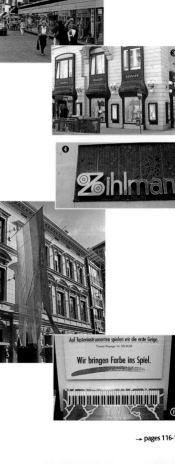

Technique ❖ Gradation

Gradation is often found in nature; it appears in the delicate color changes of autumn leaves and in the transition between the light and dark of sunrises and sunsets. As a technique, gradation uses multi-colored "rainbow" patterns to draw the eye, as is done in the sign and billboard here. The flags rely on the hue gradation R→YR→Y, which is combined with a darker tone gradation of Dp→S→B.

→ page 38 (4)

1. York, England
2. Linz, Austria
3. Vienna, Austria
4. Basel, Switzerland
5. Linz, Austria
6. Basel, Switzerland

→ pages 116-117

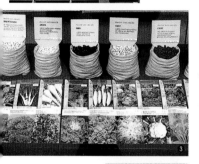

Technique ❖ Base/Emphasis

There is a solid balance of basic tone and emphasized tone in the color combinations of nature's landscape. The comfortable rhythm of red poles in a white space is seen in a train station in Budapest. The blue-based poster with apple colored-tones blends with a lamppost, also in Budapest.

→ pages 35 (1, 6), 38 (1), 43 (4), 44 (5)

Technique ❖ Color Linkage

Product names are listed on the yellow bands of green packages, which are lined up for display. Behind them yellow-and-green striped bags have been set out—a linkage with an attractive yet calming effect.

→ pages 39 (5), 40 (5), 44 (2), 46 (5)

1. Budapest, Hungary
2. Budapest, Hungary
3. Lausanne, Switzerland
4. Berlin, Germany
5. Cologne, Germany

Technique ❖ Rhythm

Color and balance become more effective depending on color control, although form also plays a role. The blue tone of the Swiss building adds rhythm and order to the wall grid, the total effect becoming one of sophisticated modernity.

→ pages 37 (4), 39 (3), 41 (4), 42 (1), 43 (2, 5), 45 (2, 3), 47 (5, 6)

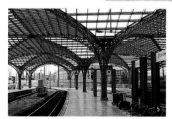

Technique ❖ Balance

The steel-framed structure in Cologne offers a sharp contrast between streamlined shape and functionalism.

→ pages 37 (2), 39 (1)

R | Fairy-Tale
Hameln, Germany

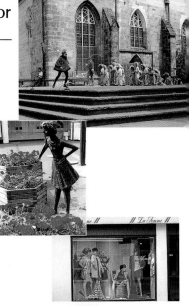

This town is associated with fairy tales, and red seems to be a popular color among the townspeople, since women wore vivid red even in summertime. Red geraniums were blooming when I visited, and the red clothes of the flute players were impressive. Red toys could be found in display cases as accents. A combination of dark red and white is used for old houses. Tourists may like the familiar red in this town because of the fairy-tale feel it creates.

YR | Delicate
Amiens, France

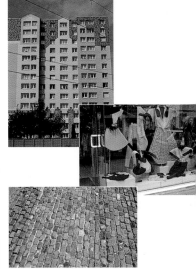

In Amiens in northern France, the delicate use of grayish colors and thin lines was impressive. A red-brown cathedral door harmonized with and was dignified by the same color scheme on the surrounding modern buildings. A display based on YR-color types highlights the town's scrumptious tonal sense. Departing from the grayish, artificial look of paved roadways common to other modern cities, this town still has brick pedestrian walks with its trademark YR regional colors.

Y Soft
Reims, France

The earth in Reims—an art school town—was a calm yellowish color. Consequently, soft and gentle yellow colors were found all over: in the hotel walls of cream yellow and in the ivory-colored train station interior, for example. The delicate sense of the soil's basic yellow toned down the strength and ardency the Y tones might have had otherwise.

G An Awareness of Green
Seoul, Korea

In Korea the green on buildings, schools, company advertising signs and cars is widespread, almost as if it filled a need.

Green is used as the basic color, and variations offer moderated richness. Yellowish-green and red combinations were also found, even on restaurant floor cushions.

B& PB Exhilarating
Bremen and Bremerhaven, Germany

Port towns like Le Havre, Copenhagen and Bremerhaven rely heavily on blue and navy. In Bremen, commercial streets are blue with contrasting yellow signs and displays. The town seems to use a cool white year round, even though fresh blue is generally considered more appropriate in summertime. Bremen has a vivid, sporty and modern feel.

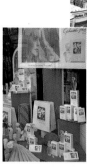

N White Simplicity
Kassel, Germany

Shining white roofs and white taxis convey the feel of Kassel. Public benches as well as the window frames of city hall were all white. Displays in fashion boutiques were simply gray and white.

The use of white in stores was very effective, giving the town a clean look. Here the regional color may be defined as white.

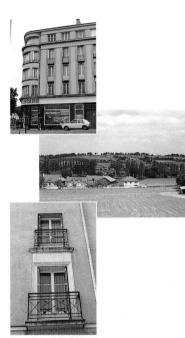

N Gray Calmness
Bretagne Province, France

Cloudy days are numerous on the Bretagne Peninsula in western France, where winds blow in from the Atlantic Ocean. Rather than strong contrasts in the landscape, a sense of calm and delicacy dominates. The Celts, who at one time lived in this province, might have used gray and white. Although their political influence eventually waned, their cultural influence can still be found in the exquisite tonal sense of the gray-and-white combinations on the exterior walls of buildings.

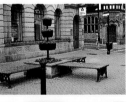

N Black Modern
Chester, England

A Japanese woman who lives in Chester once told me how attractive she found her adopted home. She was proud to show off its clean, austere beauty. Indeed, the atmosphere, with its black-and-white rhythm, recalls the lodgings of a Zen priest.

Classic and modern merge well here. The town is sharp and modern, at times even neat and dandy. Store fronts and displays come to life when chromatic color is added to the scenery's usual black and white.

Uncovering historical links often reveals regional colors. Learning about local arts and crafts and studying the color sense of local artists will allow you to not only polish your own sense of color and image, but will further disclose regional color preferences.

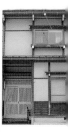

▼ Searching for a City's Identity

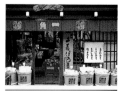

- Kyoto—Ancient culture still reigns in this old capital, home to Imperial elegance and tradition.
- Takayama—A town of craftspeople and reliable industries.
- Osaka—Commoners and merchants brought vitality to this town of commerce.
- Kobe—A town with a sophisticated Western sense.

Takayama

These four cities each rely on the basic colors of YR and Y. However, their characters, history, cultural background and geographical features are different and the Y-color group finds a separate use in each region:

TAKAYAMA
In winter, Takayama is blanketed in deep snow. The natural environment of the valley—with its rich forest—has nurtured local craftsmen. Their particular community, called Ren, began 1,000 years ago and has been instrumental in the growth of cultural images and lifestyles of other regions.

- Calm grayish yellows are seen here and there in the elegant city of Kyoto.
- Warm gray is conspicuous in Takayama, an area that receives heavy snowfall.
- Warm yellow is prominent in Osaka.
- The modern city of Kobe is awash in off-white and cream colors.

Tokyo, by comparison, uses more cool and light yellows. Let's look more closely at the history and natural features of these four cities.

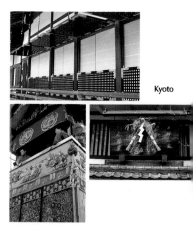

Kyoto

Kobe

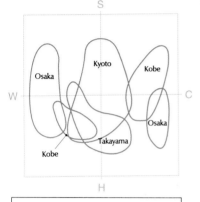

KOBE

There are many hills in Kobe. It is a port town where foreign ships come. Spring water flows from the surrounding mountains. Bakery goods and saké are among the local products. The city has adopted some Western culture and forged a modern sensibility. The influence of European traditions can be seen in its tonal sense.

- Osaka—The base tone is warm. It is cool and reasonable as a business city.
- Kobe—Chic & modern & cool & casual & smart.
- Kyoto—The changing of the four seasons can be felt. It has tradition. Natural & elegant.
- Takayama—The town retains a sense of quality even though it is influenced by the tide of modernity. Honest & dandy.

Osaka

KYOTO

For a long time, calm colors have been preferred in Kyoto, in part because the Kyoto basin limits the amount of sunlight, making the land grayish. The people have mild sensibilities rather than wild and coarse tastes. They value an elegant and refined lifestyle.

OSAKA

Osaka is warmer and receives more sunlight than Kyoto. It has long been a great bustling town of commerce and trade with an unadorned and casual lifestyle. The streets are filled with sunny, sharp and cheerful color images.

59

5 ▷ History as a Database of Color Sense

The Color and Images of *Ukiyo-e* • Exercise 1

Collecting similar images, positioning them on the image scale and then examining the different means artists use to express their individualism is beneficial "image training." Here, as in the painting section that follows, the focus is on women. Using groupings of landscape paintings, still-life paintings, posters or photographs would yield different but equally fascinating results when laid over the image scale.

In the early days of *ukiyo-e*, Hishikawa Moronobu's depictions of beautiful women were characterized by images of plumpness, benevolence, health and elegance. By today's standards, they would fall into the casual area of the word image chart.

In later works the charming sensitivity of *ukiyo-e* remained as captivating, but the mood had begun to shift. As *ukiyo-e* became more sophisticated, it reached higher levels of expression that easily met world standards.

Plotting select *ukiyo-e* on the image scale gives us a rough sense of the changes as the art form matured. (Refer to page 11 as necessary.)

1. Ishikawa Toyonobu (1711–85)
2. Ikeda-Keisai Eisen (1790–1848)
3. Torii Kiyonaga (1752–1815)
4. Suzuki Harunobu (1725–70)
5. Kitagawa Utamaro (1753?–1806)
6. Kitao Shigemasa (1739–1820)
7. Utagawa-Ippusai Kuniyasu (1794–1832)
8. Hosoda-Chokosai Eisho (drawn in 1792–98?)
9. Utagawa Kunisada (1786–1864)
10. Utagawa Kuniyoshi (1797–1861)
11. Okumura Masanobu (1686–1764)

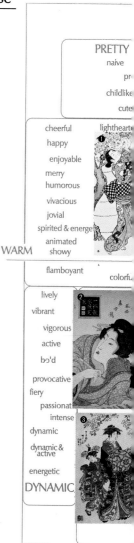

PRETTY
naive
pr
childlike
cute

cheerful lighthearte
happy
enjoyable
merry
humorous
vivacious
jovial
spirited & energe
animated
WARM showy

flamboyant
colorfu

lively
vibrant
vigorous
active
bo'd
provocative
fiery
passionat
intense
dynamic
dynamic & active
energetic

DYNAMIC

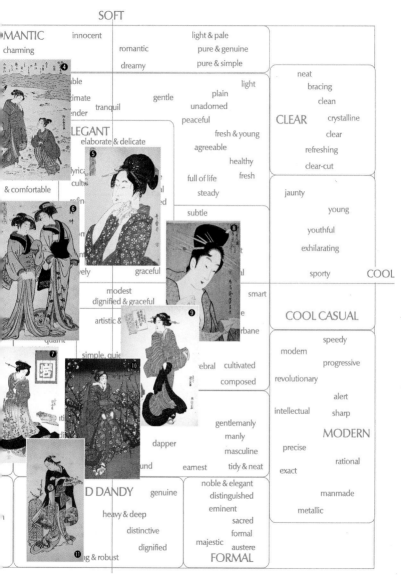

SOFT

MANTIC

charming innocent

romantic

dreamy

light & pale

pure & genuine

pure & simple

neat

bracing

clean

CLEAR crystalline

clear

refreshing

clear-cut

light

plain

unadorned

peaceful

fresh & young

agreeable

healthy

full of life fresh

steady

subtle

gentle

able

imate

ender tranquil

ELEGANT

elaborate & delicate

lyric

culte

& comfortable refin

vely graceful

modest

dignified & graceful

artistic &

simple, quie

jaunty

young

youthful

exhilarating

sporty COOL

smart

rbane

COOL CASUAL

speedy

modern

progressive

revolutionary

alert

intellectual sharp

MODERN

precise

exact

rational

manmade

metallic

ebral cultivated

composed

gentlemanly

manly

masculine

und eamest tidy & neat

dapper

D DANDY genuine

heavy & deep

distinctive

dignified

g & robust

noble & elegant

distinguished

eminent

sacred

formal

majestic austere

FORMAL

quaint

HARD

61

Superimposed on the word image scale are 16 paintings dating from 1875. Plotting paintings on the image scale reveals some interesting points patterns:

1. While most of the paintings before Impression (1870–90) would fall into the warm-hard/cool-hard area, the later efforts shown here are scattered all over the scale as painters sought more individual expression.

2. Some painters, if we were to plot the bulk of their pieces, worked for most of their career in the same area of the image scale. Others, like Picasso, changed areas as often as they changed motifs or methods.

3. When a representative selection of a printer's work is plotted, it can reveal something of the painter's psychological process.

PRETTY
naive
pr
childlike
cute

cheerful lighthearted
happy
enjoyable
merry
humorous
vivacious
jovial casual
spirited & energetic CASU
animated
WARM showy vivi

lorft
cina
t
EO
provocative ric
fiery ous
vagan
ful

1. Paul Klee
2. Vincent van Gogh
3. Pablo Picasso
4. Pierre Renoir
5. Henri de Toulouse-Lautrec
6. Maurice Denis
7. Gustav Klimt
8. Paul Gauguin

9. Claude Monet
10. Marc Chagall
11. Marie Laurencin
12. Joan Miro
13. Paul Cezanne
14. Amedeo Modigliani
15. Pablo Picasso
16. Marcel Duchamp

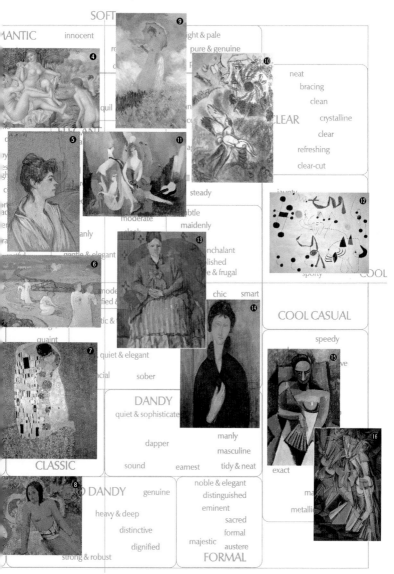

SOFT

ROMANTIC innocent

rc... ight & pale
d... pure & genuine

quil

CLEAR neat
bracing
clean
crystalline
clear
refreshing
clear-cut

ELEGANT

steady

moderate ...btle
maidenly

...anly

gentle & elegant ...nchalant
...lished
...le & frugal

moder... chic smart
...fied &
...tic &

quaint

quiet & elegant COOL CASUAL

...cial sober speedy

DANDY
quiet & sophisticate

dapper manly
masculine

CLASSIC sound earnest tidy & neat exact

DANDY genuine noble & elegant
distinguished
heavy & deep eminent
sacred
distinctive formal
majestic austere
dignified FORMAL

strong & robust

HARD

63

In the autumn of 1994 an exhibit entitled "Chinese Ceramic Arts" was held at the Tokyo National Museum. Ceramics spanning more than 8,000 years were displayed, and when viewed in toto formed a kind of database of Chinese sensibilities. A close examination of a large number of ceramics in chronological order revealed shifts, sometimes dramatic, sometimes gradual. Whenever a great change was apparent, I created a separate group. Below I have listed five groups, and the small graphs indicate each group's spread on the image scale. At right, a few representative pieces have been superimposed on the scale.

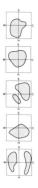

Group 1—B.C. 4000–A.D. 220
Warm type → familiar, unaffected, substantial and strong

Group 2—A.D. 300–800
Soft type → relaxed, simple, graceful and neat

Group 3—800–1100 (and celadons from 1100–1300)
Cool type → tidy, intellectual, moderate and sophisticated

Group 4—1100–1400
Hard type → distinctive, mature, sharp and chic

Group 5—1400–1800
Clear type → refreshing, precise, easy-going and rich

1. Red-glazed vase (Qing dynasty, 1644–1911).
2. Yellow vessel with green dragon pattern (Ming dynasty, 1368–1644).
3. Tricolored vase with handles (Tang dynasty, 618–907).
4. Black-glazed bottle with peonies (Song/Jin dynasties, 960–1234).
5. Bottle with scattered peonies (Qing dynasty).
6. Five-colored jar with a bird, dragon and peony pattern (Ming dynasty).
7. Celadon jar (Northern Song, 960–1127).
8. White porcelain jar (Song dynasty, 960–1279).
9. Celadon bottle (Southern Song, 1127–1279).
10. Celadon bottle with shark-shaped handles (Southern Song).
11. Underglaze-blue porcelain jar (Ming dynasty).
12. Jar with black peonies (Northern Song).

PRETTY
naive
pre
childlike
cute

cheerful lighthearted
happy free
enjoyable
merry
humorous ❶
vivacious
jovial
spirited & energetic

WARM

colorful
vibrant
❷
vigorous brilliant
active ❸
bold
provocative
fiery lux
❹

er ceful
DY tough

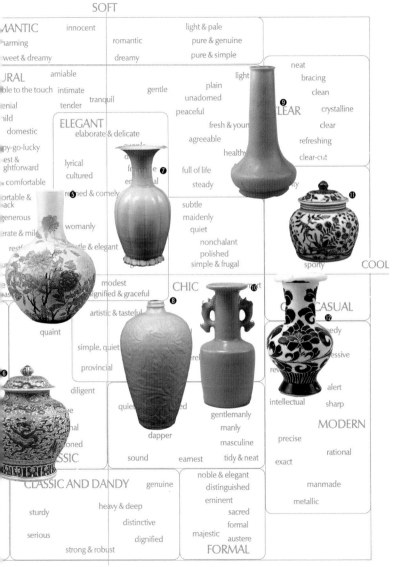

SOFT

ANTIC innocent light & pale
charming romantic pure & genuine
weet & dreamy dreamy pure & simple

URAL amiable light neat
ble to the touch intimate plain bracing
enial tender tranquil gentle unadorned clean
hild peaceful LEAR crystalline
domestic ELEGANT fresh & youn clear
py-go-lucky elaborate & delicate agreeable refreshing
est & healthy clear-cut
ghtforward lyrical fe ❼
comfortable cultured full of life
ortable & ned & comely em steady
ack ❺
generous womanly subtle
erate & mil maidenly
rest tle & elegant quiet
 nonchalant
 polished
 simple & frugal sporty COOL
❶❶

 modest CHIC
 ignified & graceful ❽ ❿
 artistic & tasteful CASUAL
quaint ❶❷
 simple, quiet edy
 provincial essive
 rev
 diligent alert
❻ quiet intellectual sharp
 gentlemanly
 nal manly MODERN
 oned dapper masculine precise
SSIC sound earnest tidy & neat rational
 exact
 noble & elegant
CLASSIC AND DANDY genuine distinguished manmade
 eminent metallic
sturdy heavy & deep sacred
 distinctive formal
serious majestic austere
 dignified FORMAL
strong & robust

HARD

3 Understanding and Using Natural Colors

① January 5	calm, deep, severe	
② April 5	relaxed, peaceful	
③ April 19	unspoiled, springlike	
④ May 21	relieved, fresh	
⑤ June 21	composed, sprightly	
⑥ August 12	active, sturdy	
⑦ October 18	calm, moderate	
⑧ November 29	splendid, rich, luxurious	

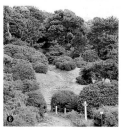

▼ Examining the Colors of Nature

When we travel, the colors of nature influence our life and outlook. Natural tones are as important as those found at home or in the office.

What kind of data can be obtained by a systematic examination of colors in a natural environment and how do colors change with the seasons? What are the psychological effects of the colors of flora? What are the effects of nature's color combinations when, say, grass and trees are viewed together? And how have people connected commercial-based colors for living with those of nature?

▼ Ecological Color Research

Some 4,000 different plants containing almost every color in the flora spectrum in Japan can be found in the botanical gardens of Tokyo University. We systematically recorded the colors by taking photographs on the tenth day of every month (in the morning). We catalogued the changes in terms of color tone and hue on the word image scale, which helped us reach an understanding of the delicate manner in which nature combines color.

Note about the garden: The copse is mainly of evergreen forest and the deciduous broadleaf forest sits on a river terrace of late diluvial formation. The grounds also include the main building and environs, a fern garden, a row of maple trees, an herb garden, a botanical specimen garden, and an azalea garden.

There is a spring on the lower bank of an alluvium, with evident erosion. As an origin of the river, it forms one element in the Japanese garden.

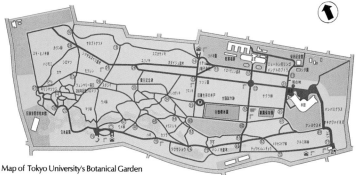

Map of Tokyo University's Botanical Garden

Winter

December

January

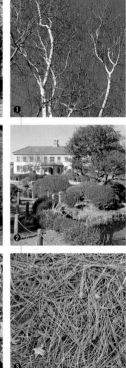

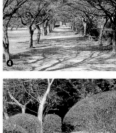

In December, ginkgo leaves are tinged with yellow, a change which began in November. However, the maple leaves have already turned red and the ground is littered with a layer of red autumn leaves.

Winter has arrived, with chic colors. The browns of the hills (unseen here) and grounds of the old medical school* provide a beautiful contrast of color tone to the reds of the school. The image of this scene recalls Japanese *wabi-sabi*, the depth of a quiet, subdued beauty.

Since ancient times, the Japanese have appreciated the beauty to be found in austerity and simplicity. Adjectives to describe this feeling include "old," "rustic," "matured," "quiet," "mysterious," "chic," "delicate," "subtle," and "profound."

In winter, plant life withers and matures, a subtle state. Tree trunks lose color tone and fade to YR. The leaves on the ground turn a soft grayish patina, offering a simple austere beauty. At the same time, Chinese quince add a more lively yellow accent. Green in winter is valuable and contrasts with the elegance of nature's withered aspect, here seen in the azaleas. The red of the lower trees and bushes in the Japanese garden echo the red tones of the old medical school. The vita

* The old medical school was built in 1876, and relocated in 196

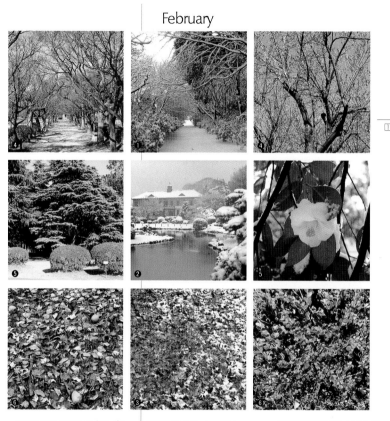

winter trees appear to have the image of "dignified," "gallant," and "clear-cut." Though it is not yet spring, a "refined," "solemn" and "deep" atmosphere pervades.

Toward the beginning of February, camellia and Japanese apricot come into bloom. Snow still lies thick on the ground, contrasting in tone to the trees and roads and forming an achromatic color coordination. The gradation of the withered leaves and the separation between the trees reinforces the aesthetic sense of snow. The image gives us a "clean" impression, occasionally "sharp" and "modern." It is a "delicate" and "intellectual" scene.

A walk in winter gives a sense of exhilaration. Natural white is bracing. It is an immaculate color which pulls us away from negativity.

Spring

March April

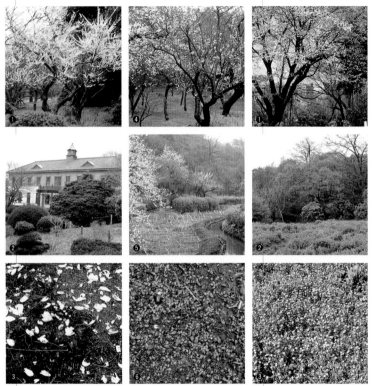

Early spring. Scene 2 is composed of white and red plum blossoms, mountain grasses and budding flowers. A calming green appears to relieve the blackish earth. The withering branches and the faint greens offset the subtle but more vivid colors of the flowers. In a landscape in which coldness still remains, these flowers exhibit "gentle," "quiet" and "dreamy" images. They are delicate, with a strong contrast. And then a spring storm scatters the seeds and petals on the ground. These are simple and clean colors. We are refreshed and feel youthful when the weather is good. The cherry trees, the willows and other greenery are still waiting for the arrival of spring.

In spring, natures' colors take on new life and vigor, and over whelm the cooler colors of winter. Cherry trees, radish flowers and wild herbs grow. The white and yellow herbs sprout into prominence, bright splashes of color against the green background of the garden. Base and contrast colors play major roles in April.

The small flowers add a sense of innocence and preciousness

May

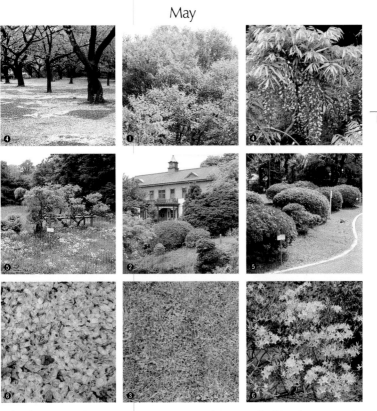

against the green ground cover, and their presence is comfortable and agreeable. This gentle color combination is one of sweetness and romance.

Japanese greens vary from GY to BG. May brings opportunities for rejuvenating walks to enjoy the various greens. It is also time to become conscious of green tones and the subtle points of their gradation. The green in Scene 1 shows obvious hue variations from G to GY and movement from deep to bright tones. In #3, the delicate shade differences of common colors become apparent. In #2, the red linkage looks

cheerful and interesting. Elsewhere, the balance of the red and yellow on green offers a friendly and open impression. May appears jovial, easy and casual.

Summer

June

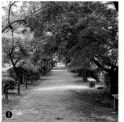

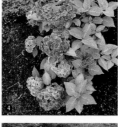

July

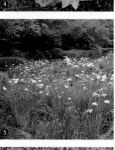

There are very few purple colors in nature. The purple of hydrangeas, wisteria and irises are prominent, as are the red lotus. Purple looks more impressive and noble during rainy-season showers, when its exuberance turns grayish. Obscured by rainy-weather mist, nature appears delicate, moderate and graceful. When the green matures later in the month, the colors become richer. The scene feels not only rustic and slow-paced, but also somewhat wild. City dwellers take away a nostalgic feeling of casual modesty and the pleasantness of the countryside.

The trees look vital; the green reflects the strong sunshine. The image is tropical but clear and vital, and natural colors turn clearer and look sharp. The greens of the garden's soft grass provide a contrasting tone sense for the hard colors in the foreground and background. The flowers become more visible against the green. The white flowers are refreshing and the red and yellow flowers are flamboyant and stimulating.

August

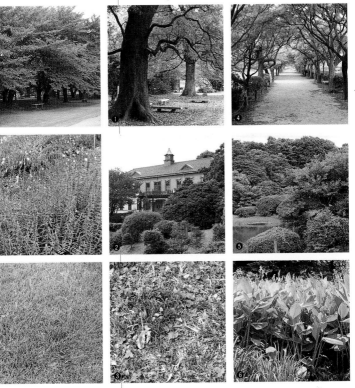

The combination of the school building's red brick and the red flowers of the crape myrtle on the green give the scene an active feel. Since the green is deep and thick, it exhibits abundant vitality and even looks passionate. In ancient times, Westerners who travelled in Japan in August were impressed by the strength and power of Japanese green. The origin of this green's richness is in the wildness and sturdiness of the GY-G tone. The Japanese have long appreciated the essence of green. They developed a pure, dynamic and wild image sensibility from the tradition of utilizing a strong sense of green.

Fall

September

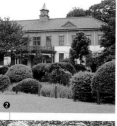

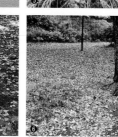

October

Green's richness fades during this season. When green darkens, it turns a grayish yellow-green. The ground is covered with leaves that have fallen and yellowed. In front of the medical school, with its combination of deep and light tones, the green begins to wither. The bush clover flowers in Scene 4 are a delicate red.

When September arrives calmly, the fallen leaves offset the green grass. The more quickly change comes, the more obviously nature weakens. In loosing its strength, the rustic and elegant atmosphere underscores the mild and sensitive feeling of nature.

Autumn arrives earlier for the fallen leaves, whose green color changes rapidly. The maples and ginkgoes have not yet changed.

The green leaves, once fallen, turn a grayish brown and beige. This change ferments the signs of autumn. It is a pure image, like that of the fallen leaves being absorbed into the earth.

Calm and faint colors remain in nature, even when it is loosing its flamboyance. The knowledge that

November

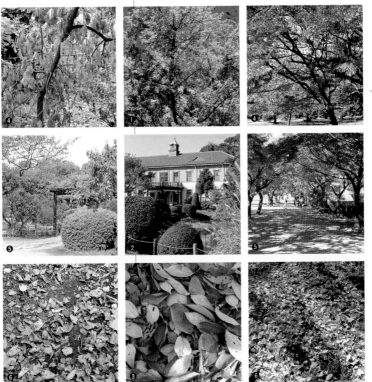

things fade away is sad, but this is a distant harbinger of the coming spring, and a sign of the vitality of nature. The fading azaleas turn a GY green and then wither to another GY in a progressive color cycle. They have a tender, emotional and noble color.

Look at a cherry leaf: its color changes from green to yellow-green, then from yellow to yellow-red, and by October it has turned a darker red. Now in November it has rich and mysterious colors. The fallen leaves have matured to an elegant red-purple. The ginkgo leaves are now yellow. They too will wither, evoking a sense of nostalgia. The autumn leaves of yellow and red are influenced by temperature

and rain. In comparing the emerging colors with the fading colors of autumnal leaves, a sense of luxury and refinement arises—this is the vibrancy and elegance of autumn.

2 ▷ Nature's Colors on the Image Scale

S

W ◀ ▶ C

H

Here, select photographs shot over a period of two years are laid out in rough order along the warm-cool/soft-hard axes of the image scale. Also see diagram on page 78.

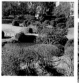

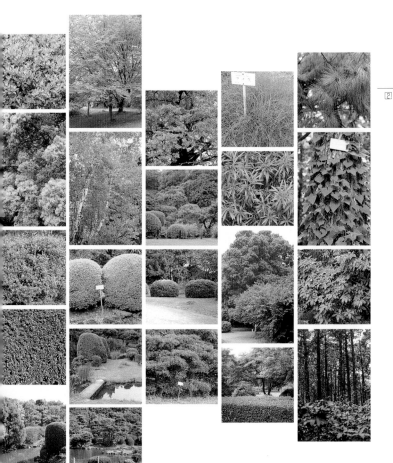

▼ The Cycles of Natural Colors and Image Changes

There are deciduous trees and broad-leaved trees. In terms of color, they can be divided into four types:

- Maple and similar-leaved trees—their hue changes from spring green GY to R.
- Ginkgoes and similar-leaved trees—their hue changes from spring green GY to Y.
- Camphor, Himalayan cedar and similar-leaved trees—their tone changes rather than the hue.
- Dwarf azalea and similar-leaved trees—both the tone and hue change.

These transitions are plotted on the image scale below. Spring greenery emerges around the middle of April and the color changes from hue G, then goes back to GY. One month later, the color turns to R and the leaves wither.

Ginkgoes also undergo hue transition from green through yellow and then wither.

On the other hand, the camphor's color transition ranges between GY and G and the tone changes from S to Dk in terms of hue when the colors of the whole tree are taken into account. The Himalayan cedar in the north experiences hue changes from G to BG and tone shifts from L to Dp. Dwarf azalea bushes show a hue change from GY to YR. The tone hovers around a grayish zone.

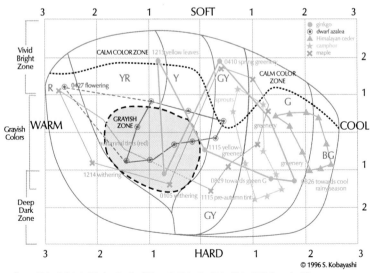

© 1996 S. Kobayashi

Seasonal Colors in Botanical Gardens. Faculty of Science, the University of Tokyo (Dates: 1115=November 15)

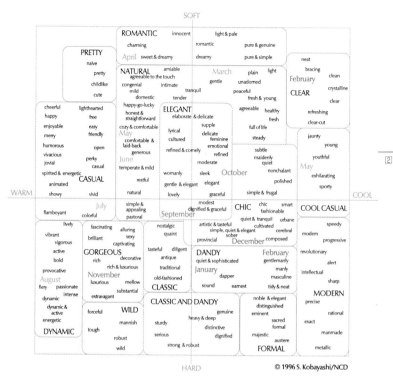

© 1996 S. Kobayashi/NCD

▼ Image Transition from January to December

In addition to the transition of green, images generally associated with the four seasons include changes in the weather, holidays and traditional events, and seasonal foods.

What distinguishes each season (and the rainy season in Japan) is a rich environment for study. Here I studied each month's character and its transitional elements, then located each month's image area on the scale. When planning with color, I hope you are able to use this method to anticipate the seasons and the unique images they present.

▼The Color Cycle of the Metasequoia

Though the character of the evergreen cedar's color cycle resembles that of the azalea's (see the diagram on page 78), the metasequoia, a deciduous tree of the same species as cedar, is known to have hue circulation similar to the maple. The metasequoia repeats the process from withering through losing leaves to spring greenery, changing its color tone.

In mid-April, the metasequoia sprouts like the ginkgo. Later it turns a soft GY green. In May, the GY strengthens to a vivid G. This vital green comes to fruition in July.

In autumn, the green fades, then reverts to a calm GY. On November 15, fall is advanced and the GY tone has turned from grayish to brown and then YR. Around the middle of December, the metasequoia's leaves seem almost to match the ginkgo's YR tone. Shining in the sun, the leaves are so vivid they bring forth images of harvest. The metasequoia's very being and richness appear different from other cedars.

Though its leaves have fallen by early January, the tree towers over the snow-covered ground of February with a quiet dignity.

In March, the metasequoia begins to sprout new leaves, a sure sign that spring is upon us.

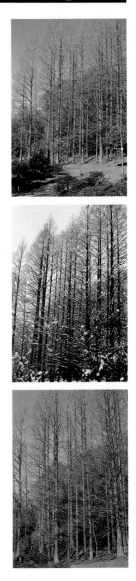

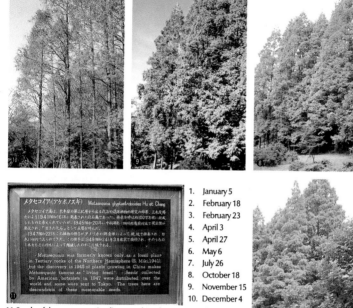

1.	January 5
2.	February 18
3.	February 23
4.	April 3
5.	April 27
6.	May 6
7.	July 26
8.	October 18
9.	November 15
10.	December 4

メタセコイア(アケボノスギ) Metasequoia glyptostroboides Hu et Cheng

メタセコイア属は、北半球の第三紀層から止まる化石植物の研究の研究者、三木茂博士により1941年(昭和16)に発表された化石属であったが、後生育地による約100万年前に絶滅したものと考えられていたが、1945年(昭和20)に中国四川省の磨刀渓で現状の生育が発見され、「生きている」として話題を呼んだ。

1947年(昭和22)、この植物の様子がアメリカの調査隊によって現地で採集され、日本へ送られてきた。その種子は1949年(昭和24)年3月末までに締結され、そのうちの1本をもとにここに育成したものがこの代木である。

Metasequoia was formerly known only as a fossil plant in Tertiary rocks of the Northern Hemisphere (S. Miki, 1941), but the discovery in 1945 of plants growing in China makes Metasequoia famous as "living fossil". Seeds collected by American botanists in 1947 were distributed over the world and some were sent to Tokyo. The trees here are descendents of these memorable seeds.

11. Seeds of the metasequoia, discovered in China, were collected by American botanists and distributed in Japan. The trees grow up to 33 yards (30 meters) high and lose their leaves in winter.

■ Metasequoia's Seasonal Changes ■

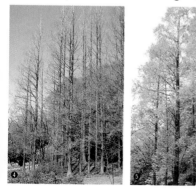

3 ▷ The Colors of Nature—
A Technique Checklist

Technique ❖ Hue Combination/Tone Combination

By observing the various color combinations of nature, we can learn more about combining colors. Nature makes a good teacher. Perhaps our ancestors, too, drew inspiration from the scenery around them.

There are differences between hue combinations and tone combinations in nature. When many hues compete with each other, they create flamboyant images. The combinations in Sçenes 1–3 attract us, exhibiting the contrast of chromatic colors against a green base.

In transitional periods, such as between spring and summer or autumn and winter, nature may cover herself in greens or browns that comfortably enter our vision with delicate light and shade. This is the meaning of tone sense.

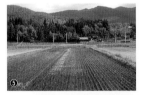

The tone effect appears three-dimensionally in the green grass base on #4, and the various autumn colors evolve against an earth color base in #5. There is another tone combination in the snowy background of #6.

82

→ pages 112–13

Technique ❖ Similarity/Contrast

Studying the natural landscape, the subtle differences of hue or tone in the gathering of hues YR or G become apparent.

1. The YR of a field fronting a stand of cedars echoes the YR of the leaves in this classic winter scene.
2. The brown trunk of a ginkgo tree is the central color here with its GY and G, hues that combine with the YR of the fallen leaves to create an autumn atmosphere.

3. Each cluster of green shows delicate differences. Look at the blue-green hedge and the yellow-green shrubbery. The commonality is quietness, but a dramatic and dynamic contrast is also evident.
4. In England, the yellow flowers extend into the distance, contrasting with the green in the foreground and background.
5. A view from the window of a train from Monaco to Italy, where legions of sunflowers offset the tree in the middle.
6. Red flowers against green grass present a vivid contrast in a southern European garden.

→ pages 114–15

Technique ❖ Separation/Gradation

Separation and gradation in nature are opposite principles of color. Separation appears as contrast and gradation as similarity.

Separation occurs when the background and foreground are divided, as the river bank divides the mountain and the river in Scene 1. The purple pansies are separated by straight bands of yellow and white in #2. The woods and the fields are vividly divided outside of Graz in #3.

In #4, from the beige shore towards the ocean, the hues change from B

to PB and the tone changes from light to dark. The subtle difference of color in the autumn leaves creates gradation in Iwate, Japan, #5. Light and shade extend in the landscape of the Alps, from the forest in the mid-ground towards the far village and mountains in #6.

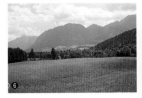

How we define clear color areas and grayish color areas depends on the length of the day.

1. A cheerful, clear color combi-nation is seen from the window traveling from Basel to Geneva.
2. The scene of a river where cool water flows with drifting water grass looks clear.
3. The white waves and the blue ocean in front of the mountains fascinates us in Rio de Janeiro. The grayish and clear colors of nature appear in the rainy season or withering season. Also the land-scape dramatically darkens on cloudy days.
4. In Kakunodate, Japan, the shades darken and the green grass is com-pletely withered.
5. As winter approaches, the land-scape in Tono, Japan, takes on the dark, faint and grayish nature of a dream world.
6. The plants have all withered, and the somber surface of the moun-tain looks chic by the Setonaikai seaside in November.

→ pages 118–19

The technique of basis, emphasis and linkage refers to a color combination used to represent the scenes clearly.

1. An opposite hue is not necessary to create base and contrast. The basic tone of green ground offsets the dwarf azaleas. When the azaleas bloom, a contrast effect comes into play.

2. The "flower clock" in Lausanne, Switzerland, works as a hue contrast.

3. White country homes are vivid in England's Lake District.

In general, linkage among natural things is hard to find, but it can be created with artificial colors, as in the following three examples.

4. A charming linkage of a red bridge, lantern and cherry flowers at Hirosaki Castle, Japan.

5. The artificial green of the benches is coordinated with the green of the trees and grass in a Cologne park.

6. A green trash can seems nonchalant and casual, set as it is alongside lake and foliage in Zurich.

The rhythm of green becomes apparent with the repetition of shape, as in the trees and shrubbery here. Balance is a state where certain rhythms are harmonized, creating a strong relationship with the green color tone. This relationship can be seen in Scene 1 in the rhythm of the poplar line in York, or the rhythm of Parisian horse chestnut trees in #2. In #3, an artificial space designed with white tiles re-enforces the rhythm of the rounded bushes. Repetition generates an image of

stillness and movement.

Rhythm and balance depend on the relationship of form and composition. Color offsets that relationship, creating fine scenes or pleasant feelings with various images.

4. The swaying lines on this slope create a pleasing rhythm and color combination.
5. The greenery and the bamboo fence are in balance at the Osaka Flower Exposition.
6. The balance of the subtly curved trees is beautifully harmonized with the background tone combination.

Even before painting theory and color method were established, painters observed nature closely. They learned by experience how to distinguish between expansion and constriction colors, progression and regression colors, stimulating and calming colors. And they also recognized how the face of nature changes in different light.

Knowledge of color has expanded to the point where laboratory research and textbooks on the subject are plentiful. It is now common knowledge, for example, that warm colors look like they are progressing, while cool colors appear to be regressing. So fall-tinged maples and ginkgoes appear grander than when they wear their spring colors. Many red buildings are appealing, while achromatic items look quiet and still. Compare the photographs at the right.

The human eye experiences physiological phenomena. While gazing unblinkingly at a certain hue, a faint hint of the opposite hue may appear. Painters exploit this phenomenon through the use of complementary color. The colorist also needs to understand how to use this phenomenon for image creation and expression.

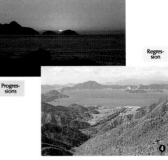

Constriction

Expansion

Regression

Progressions

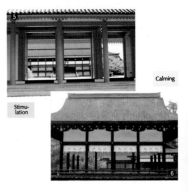

Calming

Stimulation

1. London, England
2. London, England
3. Rio de Janeiro, Brazil
4. Omishima, Japan
5. Kyoto, Japan
6. Kyoto, Japan

3

Clear Days

4

1. Near Stonehenge, England
2. Sao Paulo, Brazil
3. Omishima, Japan
4. Milan, Italy
5. Budapest, Hungary
6. Hida River, Japan

Cloudy Days

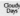

Red
R

RP

YR

P

Y

Similar hue

Similar hue

PB

GY

Opposite hue
Complementary
colors

B

G

BG

7. Kyoto, Japan
8. Koriyama, Japan
9. Vienna, Austria
10. Kiel, Germany
11. Geneva, Switzerland
12. Osaka, Japan
13. Bremen, Germany
14. London, England
15. Sakata, Japan
16. Zurich, Switzerland

It is well known that Katsushika Hokusai's *ukiyo-e* strongly influenced the late Impressionists. *Red Fuji*, as it is popularly known, is an example of expansion and progression, while *Blue Fuji* is an example of constriction and regression. From the perspective of color-coordination techniques, *Red Fuji* has a stronger hue contrast and *Blue Fuji* has the tonal effect of the light, and the shading of the color indigo. Hokusai used different

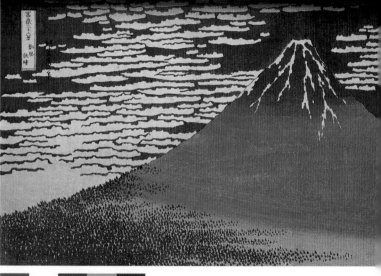

→ The clouds behind the red Mt. Fuji push the mountain into the foreground. (Psychology of progress)

expansion progression

Katsushika Hokusai (1760–1849)
On a Clear, Windy Day (1830)
From the series *Thirty-six Views of Mount Fuji*

techniques to capture the varied images of Mt. Fuji.

Landscape painters are often inspired by their awareness of the changing light. How an image is painted depends on the painter's creative process and psychological make-up. He might express the image with near photographic accuracy or he might dispense with aspects he considered incidental and depict the image in an utterly original manner.

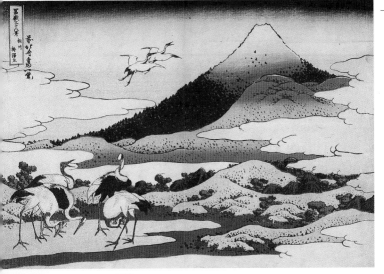

→ There is activity in the foreground of Blue Fuji. The composition and colors draw the eye to the back, giving the piece a sense of depth. (Psychology of regression)

constriction regression

Katsushika Hokusai
View from Umezawa (1831)
From the series *Thirty-six Views of Mt. Fuji*

Henri Matisse (1869–1954) used various hues and a dynamic effect of balance and movement to create his ingenious color combinations. A contrasting effect is further enhanced when the ratio on the plane is 70% base colors and 30% emphasizing colors.

Matisse painted with clear colors without over-mixing his paints. Cool colors are separated by warm colors, making his paintings dynamic and active. Here is a diagram inspired by Matisse's color images.

Transition towards images viewed from the color-coordination technique of Henri Matisse

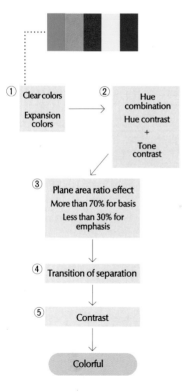

① Clear colors / Expansion colors

→ ② Hue combination / Hue contrast + Tone contrast

③ Plane area ratio effect / More than 70% for basis / Less than 30% for emphasis

④ Transition of separation

⑤ Contrast

Colorful

Pierre Bonnard (1867–1947)
Studio with Mimosa (1939–46)

Bonnard's colors here can be seen as a gradation. The studio's interior is R–YR, the mimosa seen from the window are Y. The distant view is GY–G, and B towards the sky. Through a composition of basic warm colors and an emphasis of cool colors, the perspective view is created by hue contrast. The hue coordination appears to be both light and gentle.

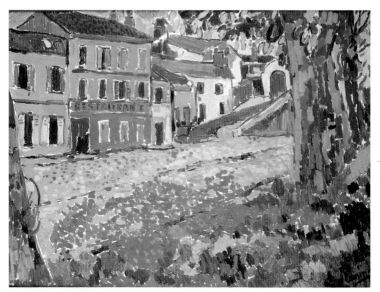

Maurice de Vlamitnck (1876–1958)
Restaurant at Marly-le-Roi (1905)

R, YR and Y hues dominate the center of the picture. The B of the background and the G–GY of the foreground add a kinetic tension. This vivid world appears in terms of hue coordination, and seems lighter and purer owing to the emphasis of the restaurant wall's R and RP and the lower windows' G. The contrast of progression colors and regression colors stimulates our aesthetic sense.

Wassily Kandinsky (1866–1944)
Improvisation Gorge (1914)

The combination of opposite colors—such as R and PB, Y and BG, YR and G—twists dynamically in this painting. This hue coordination gives the effect of progression and regression, creating rhythm and color balance. The hue variation in crossing, turning and flying shapes seems to give an auditory impression to the painting.

Paul Cezanne (1839–1906) created planes through the composition of points and lines, also combining distant, medium and close views for a three-dimensional rhythm. The distant views and the close views are connected, sometimes just with a gradation of far and close tones. Cezanne seems to construct sensitive spaces through an exploration of tone combination with a subtle rhythm.

Transition towards images viewed from the color-coordination technique of Paul Cezanne

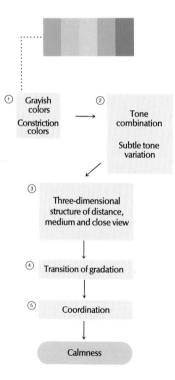

Paul Klee (1879–1940)
(1922)

Looking closely at the grayish tone combination, a clear transition of tone is apparent. The Dgr tone in the center offsets the space. Looking up from the bottom of the picture, the continuous tone gradation creates a sense of confusion, as if in a maze.

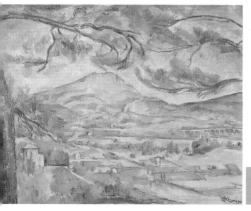

Paul Cezanne (1839–1906)
Mount Sainte-Victoire
(1885–87)

4

Ferdinand Hodler (1853–1918)
A View of Lake Leman (1905)

The tone gradation of the white clouds, and of the lake as it approaches the shore, creates a refreshing atmosphere. There is another gradation range from the horizon towards the shore of PB, B, BG, G and GY. This soft and cool image skillfully represents a clean and neat sense of Switzerland.

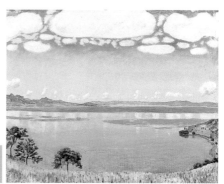

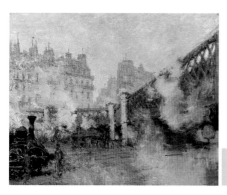

Claude Monet (1840–1926)
The Pont de l'Europe, the Gare St. Lazare (1877)

The tone effect of the cloudy sky, the smoke and the steam in Paris' St. Lazare Station is depicted here. Gradations can be seen in the sky's Y/Lgr, the buildings' Y/L, the gray station, and the dark gray locomotive. We see the movement of light and darkness in the painting's use of Y and YR hues and achromatic and grayish colors.

Creating a comfortable living environment through urban planning and product design depends on coordinating natural and artificial colors.

Exercise 1: Imagine how people live with color. For instance, imagine a clear, yellow-ivory colored bridge lined with 20 empty flower containers in a row. What color flowers would you arrange in the pots to harmonize with the artificial color of the bridge?

▼ Idea 1 < Linkage and Tone Effect>
Yellow flowers may work well for the ivory bridge to create a tone effect and linkage.

▼ Idea 2 < Basis and Emphasis>
In the case of a large bridge, the first idea would be inadequate, bringing too simple a rhythm to it. Not everyone passing may notice the flowers, so yellow flowers should be used as a basis, with purple flowers arranged in containers at regular intervals to create an alternating rhythm. People would feel comfortable with this gentle but arresting combination.

Exercise 2: Imagine the properties A, B and C are situated side by side, with B being a traditional Japanese house made of natural materials surrounded by a hedge. The owners of A and C on either side are planning to build houses using artificial materials. Which color would you use for A and C to link them to B, considering the street environment?

▼ Idea < Linkage and Tone Effect>
For A, you might use white-framed material in a Lgr tone of a GY hue. GY works well with the green hedge.

C's exterior wall could be brick in the same or similar hue as that of B's YR wall, matching its tonal effect. In this way A, B and C are linked in the exterior color network.

In urban life, it is important to bring nature in and to maintain a certain comfort level. On the other hand, in rural life we need to think about how to live with nature and to control the artificial items and colors that are allowed in.

To handle this, we should understand that nature does not confront artificiality, but coexists with it. Ideas should come from the subtle combination of colors in nature to find and develop color-coordination techniques. We will learn more about that in chapter four.

Technique ❖ Hue Combination

1. The hue combination of the natural flowers and manmade screens at the '90 World Design Exposition in Nagoya is exquisite.

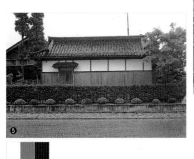

2. Japanese New Year decorations have the coherence of YR oranges, a R tablecloth and celebratory fans.
3. A flower bed in Lausanne, Switzerland. R, Y and RP offset the green ground to create a hue effect.

Technique ❖ Tone Combination

4. A tone effect exists where the bamboo frame and living bamboo combine with the wall's YR.
5. A house by a paddy field exhibits its tone sense, blending well with the charming surroundings in Toyama, Japan.
6. The green of Lake Zurich reflects the building walls for a tone effect.

Technique ❖ Similarity

1. A trash storage area, apt to be avoided by people, is covered in ivy for a clean tone effect in Geneva, Switzerland.
2. An unique fence on a public street in Nagoya is comfortably integrated with the background green.
3. The green of the summer grass is set against tall trees, lending a nostalgic image to the old capital of Nara.

Technique ❖ Contrast

4. Developing a contrast technique requires the effects of basis and emphasis. Bright flowers (emphasis) are offset by a green ground and a row of trees (base), creating a remarkably charming scene in Vienna.
5. The two warm reds are conspicuous, particularly against a green background. They add tension and give the scene a flamboyant atmosphere.
6. The ocher wall works with the dark green as a tone contrast in the royal palace of Vienna.

→ pages 114–15

Technique ❖ Separation

1. The red flower line separates the street from the inner ground, giving a sense of warmth in Graz, Austria.

2. The ginkgo's yellow leaves separate the sidewalk from the main road, emphasizing autumn's pathos and sensitivity in Kakunodate, Japan.
3. The curving artificial road separates the green in a subtle balancing effect.

Technique ❖ Gradation

4. A warm gradation of winter foliage.
5. A gradation of autumnal leaves fronting a five-storied pagoda of Ninna Temple in Kyoto.
6. A combination of the forest's dark green, the green of the bridge, the beige fence and the brown train rails blends layers of natural and artificial colors.

→ pages 116–17

A conspicuous effect is required to achieve a successful contrast color combination, and base and emphasizing colors must be considered. How colors are to be separated must also be taken into account.

1. Yellow-orange walls (basis) in the building's interior combine well with the GY/Y/YR exterior, and a splash of natural green (emphasis) creates a refreshing scene for passengers at a Budapest station.

2. Sasayama, Japan, is a traditional town, and the vivid flowers (emphasis) in the wooden planter box in front of a classical door lend a touch of grace and elegance.

3. The park bench (emphasis) is in clear Y, and other cool yellows are seen here and there, mixing well with varied features in Innsbruck.

Technique ❖ Linkage

Linkage requires the connecting of colors. The successful linkage of natural and artificial colors in these scenes allows both types of color to coexist.

1. Wine bottles and fresh grapes are linked in this subtle display in York, England.
2. Natural colors give a remarkable warmth to this scene in the snowy town of Takayama, Japan. Also, R and YR hues are linked with the lattice work and signboards.

3. Green lettering and decorative plantings are linked at the entrance of a Vienna restaurant to emphasize its good taste.

⑤

Technique ❖ Rhythm

People prefer steady change to sudden change. The feeling helps to create a certain rhythm.
1. The manmade blocks are set rhythmically against the natural green in a controlled tone.

2. Pleasing rhythms are apparent in the woodwork of the shrine and the white holy amulets.
3. The rhythmic placement of statues adds to the stateliness of this site.

Technique ❖ Balance

The idea of balance works when symmetry is broken in ways that create dynamic tension.
4. The balance of nature is artificially incorporated into a landscape to create a comfortable space in Lille, France.

5. Manmade dishes are coordinated with natural elements in a YR balance in Linz.
6. This street was designed to achieve a balance of curving brickwork in Lausanne, Switzerland.

The colorist should learn not just the theory behind combining colors but also where and how to apply its techniques.

The list below was created after extensive on-site research of scenes with natural elements, artificial items, and combinations of both.

Knowing which technique to use in which situation will allow you to use color techniques more effectively.

Techniques Documented in the *Colorist* (Stars signify frequency of use)

Color technique \ Scene	Natural elements	Artificial items	Natural + artificial combinations	
Hue combination	✔	★★	✔	Hue coordination is often seen in artificial space.
Tone combination	★★★	★	★★★★★	A mixture of natural and artificial elements creates comfortable tone feeling.
Similarity	★	★★	✔	An example of well-coordinated natural and artificial colors is rarely seen.
Contrast	★	★★	★★★	Manmade color works better in contrast. The mix is more effective.
Separation	✔	★★	★	Light, shadow, snow and waves are good examples of natural separation.
Gradation	★ ✔	★	✔	Natural and artificial colors can be combined as gradation.
Clear colors	✔	★	★	The competition of both colors can work well, especially in resorts.
Grayish colors	✔	★	★★	Caution should be exercised if the artificiality is more visible.
Basis and emphasis	✔	★★	★★	We should seriously consider the effect when both are mixed.
Distinctiveness	★	★★★★	★★★	Natural materials look attractive in a manmade background.
Color linkage		★★	★	Natural and artificial colors should be related well in terms of color combination.
Rhythm	✔	★★		It is rare to see a good arrangement of natural and artificial colors.
Balance	★	✔	★	Many examples of balance can be found in natural landscapes.

4 Color-Combination Techniques
Color Psychology

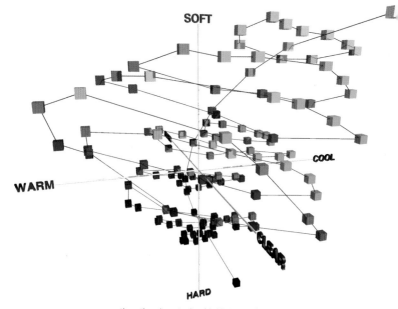

Above: Three-dimensional model of the image scale on page 12 (illustration by Yasunari Nishimura.).

▼ Interpreting Colors

We have explored regional and natural colors, now let's look at the psychological nuances of color and how they are represented on the color image scale. In the preceding chapters we have dealt with a two-dimensional image scale with two axes, warm/cool (WC) and soft/hard (SH). To fully grasp the ideas of color, we need to explore a third axis of clear/grayish (KG), which adds to the scale a third dimension that allows us to measure, in impressionistic or psychological terms, the amount of gray in a hue or tone. In the following six pages, each axis will be discussed in detail and examples will be given, then techniques of color combination based on the ideas presented will be introduced.

Recognizing differences in hue, value and chroma (HV/C) comes naturally to some, but for most people careful study and comparison are required. Though analyzing colors with the three-dimensional image scale is a suitable beginning, extra effort is needed to apply this method to an actual living environment and work space. The image scale serves as a skeletal base on which to hang your impressions and results, and from which you can eventually draw plans and color schemes of your own. Avoid the tendency to imagine each color range too broadly, or take it too literally or too poetically, obscuring the real meaning.

Remember, the hue and tone system on pages 8–9 was created so that anyone interested in color could determine differences easily and deal with colors more objectively.

Three-Dimensional Image Scale

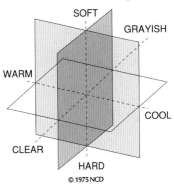

© 1975 NCD

→ pages 11, 12, 14

The Warm/Cool Axis

The warmth and coolness of hue

→ This hue dial is comprised of 40 hues, making it possible to easily distinguish the transitions from one hue to the next. The Munsell system divides one hue into ten elements.

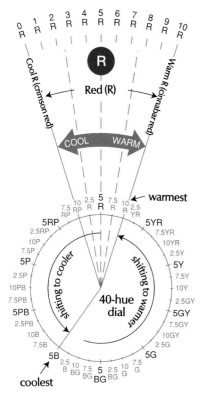

Study the dial for a moment. Cinnabar red, 10 R on the dial, is the warmest point. Moving either clockwise or counterclockwise, colors become cooler until reaching 5B.

From the WC perspective, we can see subtle differences in color within the same color range. For instance, a banana's color is warm and a lemon's is cool, even though both are yellow. In like manner, in the blue range the navy hue 5PB is a little warmer than 5B.

The WC tone works in the same way. Though 5YR generally has a warm hue, we feel its vivid tone is the warmest, becoming cooler as it shifts towards the Vp tone. Within the cool hue 5B, the coolest designation is the B tone. The Dgr tone drops to a low B cool rate.

Tone Diagram of Warm and Cool
The numbers in the diagram indicate coolness (−) and warmth (+).

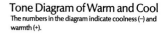

Warm R

← R →

Cool R

1. Hamburg, Germany

2. Linz, Austria

3. Caen, France

Warm Y

← Y →

Cool Y

4. Kobe, Japan

5. Lyon, France

6. Hamburg, Germany

G

warmer — G — cooler

BG

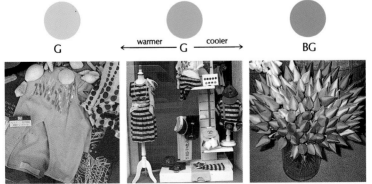

7. Kobe, Japan

8. Paris, France

9. Bangkok, Thailand

The Soft/Hard Axis

The second psychological axis, soft / hard, contains elements of shared human experience. Among others, it embodies a sense of weight (lightness or heaviness), brightness (light or darkness), and tactility (softness or hardness). SH is fundamentally linked to weight. Its tone sense expresses the basis of daily life.

How we connect color images with the elements such as materiality, design, taste and sound depends on this SH axis.

4

Soft/Hard's Opposing Images

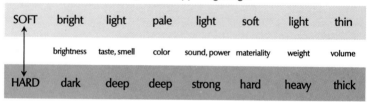

SOFT	bright	light	pale	light	soft	light	thin
	brightness	taste, smell	color	sound, power	materiality	weight	volume
HARD	dark	deep	deep	strong	hard	heavy	thick

Tone Chart of YR Hue

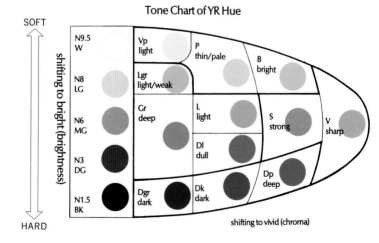

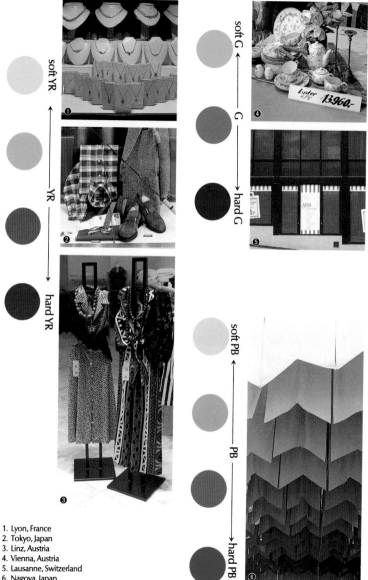

soft YR ← → YR → hard YR

soft G ← → G → hard G

soft PB ← → PB → hard PB

1. Lyon, France
2. Tokyo, Japan
3. Linz, Austria
4. Vienna, Austria
5. Lausanne, Switzerland
6. Nagoya, Japan

The Clear/Grayish Axis

WC or SH ratios of single colors can be easily recognized, possibly because they are close to what we ascertain intuitively. However, the third psychological axis, clear/grayish (KG), is based on changing sunlight. It is difficult to catch the subtle difference of reflective light on the KG plane. Thus, a general discussion of tone areas will prove more useful than a detailed look at a few sample colors:

• Clear tones encompass B, V, Vp and P without gray. Vp or P tones turn grayish when a room becomes dark, and their impression may also change under varying light conditions. In dim or bright light, off-white or light gray may easily be mistaken for white.

• The highest ratio of gray appears in Lgr and Gr tones and in the light gray and dark gray of the achromatic scale, colors that are visible in chic images.

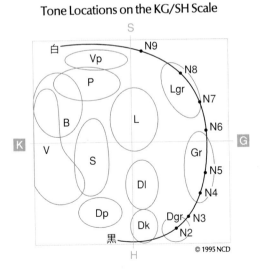

Tone Locations on the KG/SH Scale

© 1995 NCD

• S and Dp tones are grayish, with relatively high chroma sometimes appearing to be clear colors, depending on the light.

• L, Dl, Dk and Dgr tones occupy a middle ground in the center of the KG axis, neither too clear or too grayish, and can be categorized as fixed and calm colors. The KG axis is suitable for selecting images to learn the subtle materiality of textures and glosses.

→ "K" indicates "Clear" and "C" stands for "Cool."

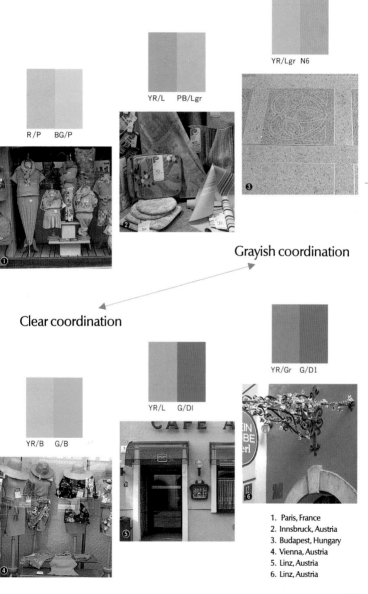

R / P BG / P

YR/L PB/Lgr

YR/Lgr N6

Grayish coordination

Clear coordination

YR/B G/B

YR/L G/DI

YR/Gr G/D1

1. Paris, France
2. Innsbruck, Austria
3. Budapest, Hungary
4. Vienna, Austria
5. Linz, Austria
6. Linz, Austria

Technique ❖ Hue Combination

→ The color positions on the image scale found on pages 112–19 are based on the single-color image scale introduced on page 12.

4

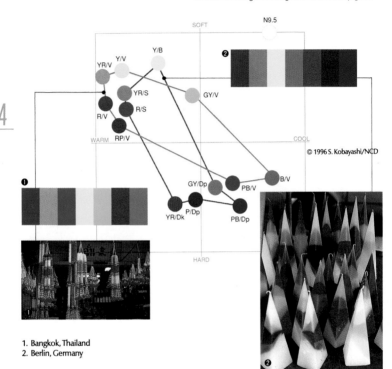

© 1996 S. Kobayashi/NCD

1. Bangkok, Thailand
2. Berlin, Germany

When combined colors spread out on the image scale towards WC, the hue effect becomes stronger. Looking at V, S and B tones in higher chroma on the single-color scale on page 12, the connecting lines between colors span the scale, showing the extent of the difference between each hue's WC ratio. This gives us a basis to conduct image analysis of the color combinations in these photographs.

In Photo #1, as the colors extend towards WC, the contrast of the various hues becomes stronger. In #2, each hue has its own light and shade effect, and extends towards SH with the contrast of basic white and surface colors.

→ pages 50, 82, 97

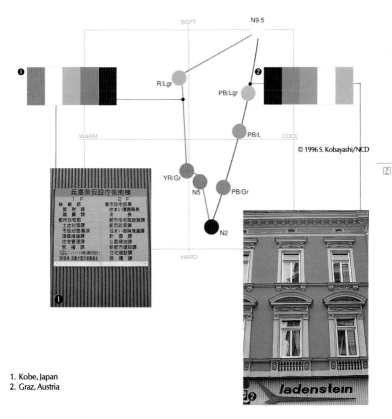

© 1996 S. Kobayashi/NCD

1. Kobe, Japan
2. Graz, Austria

Asian *sumi-e* ink drawings reveal a world of delicate light and shade with varying levels of brightness in achromatic colors. An SH tone image appears when colors with different brightness levels but the same hues are combined. If the color is sampled vertically on the scale, the more hue added, the more effective the tone technique.

Photo #1 is a good example of a tonal combination: a beige directory board against a gray background, with black characters sitting on a white line. The tone effect in #2 blends walls, window frames and even the characters on the sign.

→ pages 50, 82, 97

4

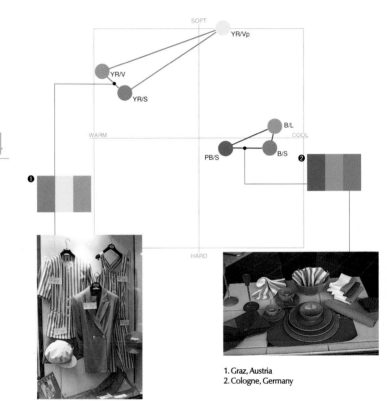

1. Graz, Austria
2. Cologne, Germany

Color coordination consists of either combining similar colors or contrasting different colors. On the scale, closer colors are easily coordinated, as are similar or grayish colors. In Photo #1, a white accent is combined with a light and dark orange base. The ivory wall also offsets the orange as a tone effect. Photo #2 shows an example of the coordination of similar colors. A tone gradation effect is achieved using the clean colors of blue turquoise and white.

Refer to page 119 for a discussion on the coordination of grayish colors.

114

→pages 51, 83, 98

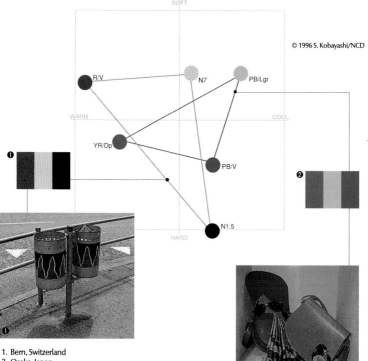

© 1996 S. Kobayashi/NCD

1. Bern, Switzerland
2. Osaka, Japan

Contrast appears when opposite colors or vivid tones with rich hues are combined. This technique is normally used to attract attention to displays, signs or other objects meant to draw the public interest. The red (R/V), silver gray (N7) and black (N1.5) of Photo #1 are located far apart from each other on the scale, and the combination evokes an array of images and feelings. The display in #2 effectively links the scarf to bags of opposite colors.

→pages 51, 83, 98

115

4

© 1996 S. Kobayashi/NCD

1. Sendai, Japan
2. Aachen, Germany

Inserting heterogeneous colors between two related colors is a separation technique, another type of contrast. It gives a feeling of movement and adds clarity to color combinations. The bus panel in Photo #1 is an example of a hue separation of opposite colors and #2 shows a tone separation where white fortuitously comes between grayish colors.

This technique is usually effective in creating a sporty and moving atmosphere. It is also used to provide contrast for grayish color combinations or gradation. Separation works well when achromatic colors are added to the mix, particularly in modern building façades.

→ pages 52, 84, 99

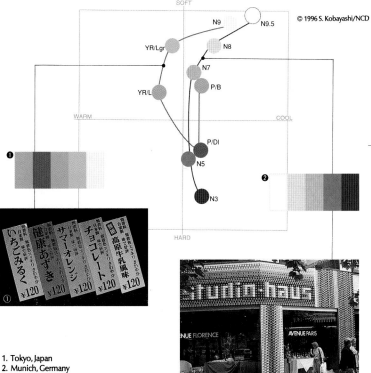

© 1996 S. Kobayashi/NCD

1. Tokyo, Japan
2. Munich, Germany

There are a number of ways to achieve an effective gradation: arranging colors clockwise or counterclockwise from warm to cool, or light to dark, are but two. Colors shift horizontally on the image scale in terms of hue gradation, and vertically in terms of tone gradation.

The connection of P and YR as opposite hues in a subtle yet arresting combination can be seen in Photo #1. In the coordinated window trim and shop name in #2, achromatic colors guide the eye from light to shade, then to light again.

→ pages 52, 84, 99

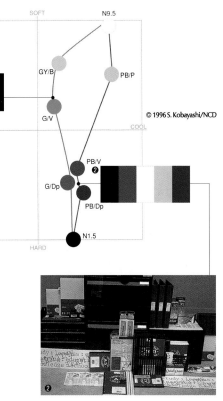

© 1996 S. Kobayashi/NCD

4

1. Milan, Italy
2. London, England

Fresh, calm colors may be found around the edge of the WC/SH scale, and calm-grayish colors near the center. Achromatic colors appear clean and clear without sediment. When these types of colors are combined, they make whole images lighter. B, V, P and Vp tones are categorized in the calm and chromatic color group. More than any other hues, B, PB and BG hues can create a clearer atmosphere. Examples include the white base color offsetting the green packages in Photo #1 and the blue emphasizing the contrast of black and white in #2.

→ pages 85, 110

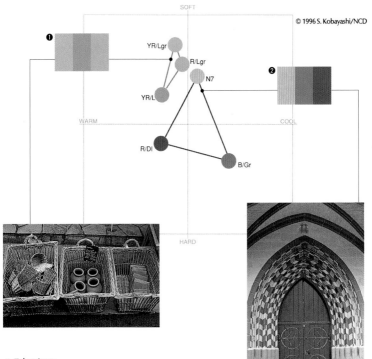

© 1996 S. Kobayashi/NCD

1. Tokyo, Japan
2. Gottingen, Germany

Building a bold contrast with Lgr, L, Dl or Gr colors in quiet tones with gray is challenging because they have a delicate tranquility under cloudy skies or in indirect lighting. Grayish colors look dull and lose their temperate flavor when placed alongside gaudy colors or bright lights. Though they have reserved tones, it is fine to use them on basic colors for everyday life.

The basketry and unglazed pottery in soft gray are elegantly coordinated with the gray of the stone pavement in Photo #1. The light and shade pattern on the wall enhances the tonal effect of the deep-colored door in #2. The repetitive-pattern decoration of the arch functions as a linkage device.

→ pages 85, 110

When single colors with a certain image are connected to other colors, the entire image changes, just as the meaning of a sentence may change when a certain verb, adjective or adverb is inserted. However, the new image does not usually change substantially, as a link with the original color's image remains.

When creating a unique image from scratch, the first step is to determine the main color image and then select suitable combinations. You also need to know how many colors should be used for your desired image.

Combining Clear and Grayish Colors

Vienna, Austria

Generally, it is hard to garnish Gr or Dl tones with V and B tones because the basic image of clear colors is different from the image grayish colors project. However, by altering the proportion of base to emphasizing tones this problem can be overcome.

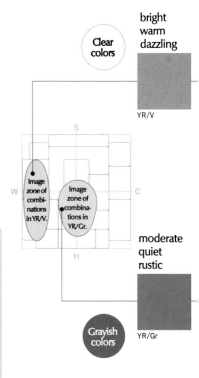

bright
warm
dazzling

Clear colors

YR/V

moderate
quiet
rustic

Grayish colors

YR/Gr

→ *Color Image Scale*, pages 34, 41
→ *A Book Of Colors*, pages 30–41

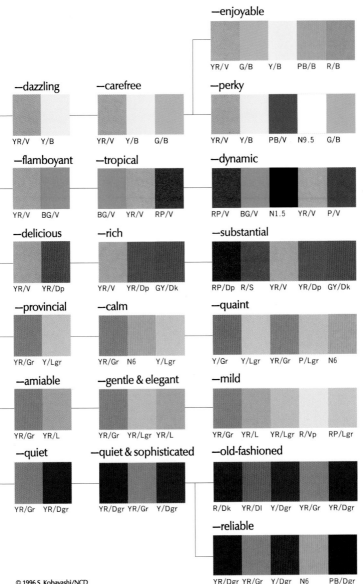

—enjoyable

YR/V G/B Y/B PB/B R/B

—dazzling

YR/V Y/B

—carefree

YR/V Y/B G/B

—perky

YR/V Y/B PB/V N9.5 G/B

—flamboyant

YR/V BG/V

—tropical

BG/V YR/V RP/V

—dynamic

RP/V BG/V N1.5 YR/V P/V

③

—delicious

YR/V YR/Dp

—rich

YR/V YR/Dp GY/Dk

—substantial

RP/Dp R/S YR/V YR/Dp GY/Dk

—provincial

YR/Gr Y/Lgr

—calm

YR/Gr N6 Y/Lgr

—quaint

Y/Gr Y/Lgr YR/Gr P/Lgr N6

—amiable

YR/Gr YR/L

—gentle & elegant

YR/Gr YR/Lgr YR/L

—mild

YR/Gr YR/L YR/Lgr R/Vp RP/Lgr

—quiet

YR/Gr YR/Dgr

—quiet & sophisticated

YR/Dgr YR/Gr Y/Dgr

—old-fashioned

R/Dk YR/Dl Y/Dgr YR/Gr YR/Dgr

—reliable

YR/Dgr YR/Gr Y/Dgr N6 PB/Dgr

© 1996 S. Kobayashi/NCD

▼ Formation of a Color Sense

Humans unconsciously absorb images through their daily environment, their senses and communication with others. This process begins in childhood. For instance, children are easily impressed by a bright scene. A multicolored flower bed of tulips might elicit an excited reaction. "Wow! That's pretty!" a child is apt to say. Such an image would then be impressed on the mind, and the flowers' colors imposed onto the mental database and categorized as a "pretty" image.

In this manner, familiar images are impressed on the senses over time. A series of such images inscribed on the heart and mind determines a person's taste and lifestyle.

▼ Psychological Development, Word Images and Color Sense

A rich living environment is necessary to encourage and nurture a child's creative sense. To develop fully, a child needs a solid stock of healthy images. Below are some adjectives chosen from (Japanese) elementary school textbooks. Can you see how the words' nuances are connected to the color schemes?

Milan, Italy

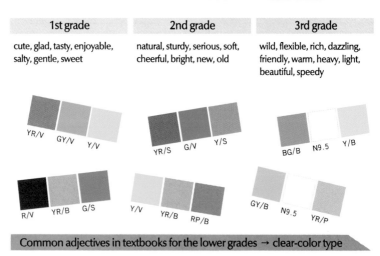

1st grade	2nd grade	3rd grade
cute, glad, tasty, enjoyable, salty, gentle, sweet	natural, sturdy, serious, soft, cheerful, bright, new, old	wild, flexible, rich, dazzling, friendly, warm, heavy, light, beautiful, speedy

Common adjectives in textbooks for the lower grades → clear-color type

Comparing the adjectives with the word image scale on page 11, there are many WS-related words and only a few "darker" words. Many appear to be based on associations with mother or family.

As a child matures, "deeper" words approaching adult sentiments begin to appear. The budding youth becomes conscious of fashion and exhibits self-assertion. His range of nuance expands and he recognizes the worth of clear colors and even gray colors.

By junior high school, his range of knowledge starts to encompass not only concrete objects but also abstrac-

A school in Marseilles, France

tions. Through communication with others and the influence of his environment, individual taste, value judgment and identity begin to blossom, leading to a deeper awareness of design and color.

A child's daily life revolves around inanimate objects, such as books, magazines, television and computers. In a world that is increasingly mechanical, a child's environment can become quite dull. Take a look at your surroundings in terms of color combina-

Kita Kyushu, Japan

4th grade	5th grade	6th grade
pleasant, healthy, calm, simple, quick, funny, quiet, reliable, robust, nostalgic, bitter, clean, still	easy, vivid, flamboyant, bold, elaborate, eminent, elegant, peaceful, refreshing, noble, complicated	showy, sunny, restful, sensational, cultural, detailed, flexible, smooth, brand-new, cool, magnificent

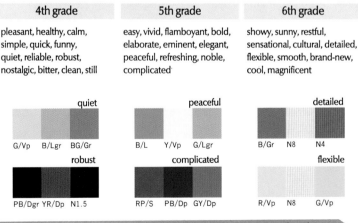

quiet

G/Vp B/Lgr BG/Gr

peaceful

B/L Y/Vp G/Lgr

detailed

B/Gr N8 N4

robust

PB/Dgr YR/Dp N1.5

complicated

RP/S PB/Dp GY/Dp

flexible

R/Vp N8 G/Vp

Common adjectives in textbooks for the higher grades → grayish-color type

A school excursion

tions. Will it nurture a child's growing sensibility? Is it biased or overly simple?

The family—and the mother in particular—contributes to a child's image training. The colors of the classroom, playground, school buildings, and the clothing of teachers and friends are also important to consider. Children should be allowed to experience colors, thereby enriching their inventory of feelings and images.

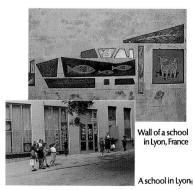

Wall of a school in Lyon, France

A school in Lyon

7th grade	8th grade	9th grade
relaxed, young, quiet & sophisticated, withered, subtle, graceful, immersed, majestic, practical, dry, strange, pleasant-smelling, pure, luxury, straightforward	sunny, crowded, wild, dignified, tranquil, placid, traditional, naive, homely, pale, fresh	active, charming, soft & gentle, auspicious, radical, austere, delicate, comfortable, powerful, dignified, wet, sophisticated, sturdy & powerful, exquisite, noble & elegant

pleasant-smelling

BG/Vp G/P G/Vp N9.5 B/Vp

young

BG/B Y/P PB/V N9.5 B/B

tranquil

GY/Lgr GY/Vp Y/Lgr Y/Vp YR/Lgr

pale

PB/Lgr N9 N8 N9.5 PB/Vp

delicate

YR/Vp N9.5 RP/Vp R/Lgr R/Vp

sophisticated

PB/Gr P/Lgr N8 N9 B/Lgr

Common adjectives in textbooks for the higher grades → tone sense

Human Communication
Color as a Window on Family and Friends

We used the color research exercise on pages 6–7 as a tool to uncover associations between color and people's perceptions of family and friends. In addition to choosing the colors they liked and disliked, we asked participants to choose colors to describe their father, mother, brothers and sisters, superiors and friends.

Forty male and sixty female employees in their twenties through their forties participated in this 1995 study. The following four charts convey the results and are based on the hue and tone system introduced on pages 8–9. Refer to pages 140–41 for further commentary on this study.

Image of Mother

1st RP/L
2nd P/S
3rd R/S, RP/Dl
4th P/P, RP/V

COMMENTS
• Converging on R, YR and RP in warm colors.
• Many grayish colors of P or RP/L are associated with mature women.

	R	YR	Y	GY	G	BG	B	PB	P	RP		N
V	■									■		
S	■					■		■				
B	■											
P	■									■		
Vp												
Lgr												
L										■		
Gr												
Dl										■		
Dp	■											
Dk	■											
Dgr												

Image of Father

1st YR/Dgr
2nd R/Dk, B/Dgr, PB/Dgr

COMMENTS
• Many are of a darker tone.
• A reliable, calm and slightly dignified image of the father emerged.

	R	YR	Y	GY	G	BG	B	PB	P	RP		N
V												
S								■				
B												
P												
Vp												
Lgr												
L												■
Gr		■										
Dl								■				
Dp												
Dk	■	■		■		■		■				
Dgr		■	■	■	■	■	■	■				

Human Communication
Color as a Window on Family and Friends

Image of Friends

1st Y/B
2nd Y/P
3rd Y/V, PB/Dp

COMMENTS
• The selection of vivid and bright ones represents the joy of communicating with friends.

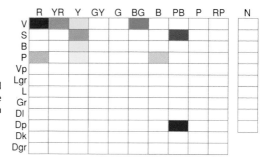

Image of Superiors

1st N3
2nd PB/Dgr
3rd B/Dk
4th B/Dgr, N2

COMMENTS
• Mainly plain, dark tones.
• Similar to the distribution seen for the father and grandfather.
• The "hard" image of the businessman predominates.

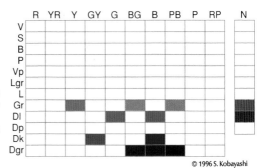

© 1996 S. Kobayashi

Image of Grandfathers	**Image of Grandmothers**	**Image of Brothers**	**Image of Sisters**
1st YR/Gr	1st P/Gr, RP/Dk	1st PB/V	1st RP/V, RP/B, RP/P
2nd Y/Gr, GY/Dgr	2nd R/Gr	2nd PB/S	2nd R/B
3rd YR/Dk, Y/Dk, BG/Dk, B/Gr	3rd R/Dk	3rd PB/Dl	3rd YR/P, Y/P, RP/L
		4th PB/B	

COMMENTS

Grandfathers: • The results show a more natural image than that of father. • Preferences are for dark and grayish tones of YR through B, but less navy.

Grandmothers: • There are more YR and quiet tones of P through PB.

Brothers: • The mix of a vivid and bright tone of cool G through PB suggests an image of youth.

Sisters: • Many vivid and bright tones. • The selection may explain the cheerful and soft image we have of sisters.

5 Color for Personal and Business Settings

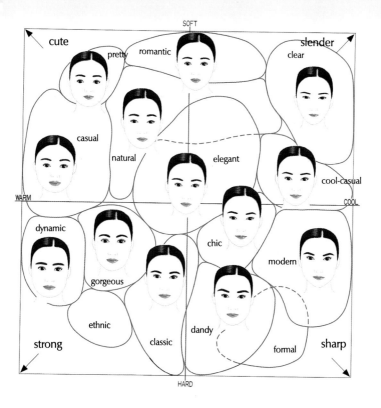

SOFT

cute

pretty

romantic

slender

clear

casual

natural

elegant

cool-casual

WARM

COOL

dynamic

chic

modern

gorgeous

ethnic

classic

dandy

formal

strong

sharp

HARD

Chapter 1 dealt with recognizing your own color sense as the first step in becoming more aware of the possibilities of color. Chapter 2 explored how to ascertain regional colors. Natural transitions and seasonal cycles were examined in Chapter 3, and color-combination techniques were discussed in Chapter 4. In Chapter 5 we will look at 8 color profiles and examine how color preferences can be defined in personal and commercial settings. Specifically, this chapter will focus on four areas:

1. Compiling data of individual tastes and emotions based on color and then taking a detailed look at popular taste profiles.
2. Comparing business and family settings.
3. Opening the door on a wider perspective and giving tips for inspiration and further applications of the principles introduced in this volume.
4. Examining the commercial aspects of color by viewing people, products, advertising and merchandising efforts through the lens of the color image scale.

▼ Color Profiles

In order to determine the "color profiles" on the pages that follow, we researched the color tastes of 820 subjects using a selection of 5-color combinations. The results were then broken down into preferences, or "types," making it possible to concretely measure the differences. (Though the participants only viewed color combinations, this method can be applied to other subject matter if the image word scale [page 11] or combination scale [page 15] are used together with data from photographic research.)

The most popular color combinations were

1.	clear	6.	refined
2.	elegant	7.	quiet
3.	delicate	8.	simple
4.	fresh	9.	natural
5.	calm	10.	grace

The least popular combinations were

36. radical
37. dynamic
38. luxury
39. strong
40. rich

Our research also showed that many participants liked cool-soft or grayish images and combinations, with warm-hard and heavy color combinations being the least favorite.

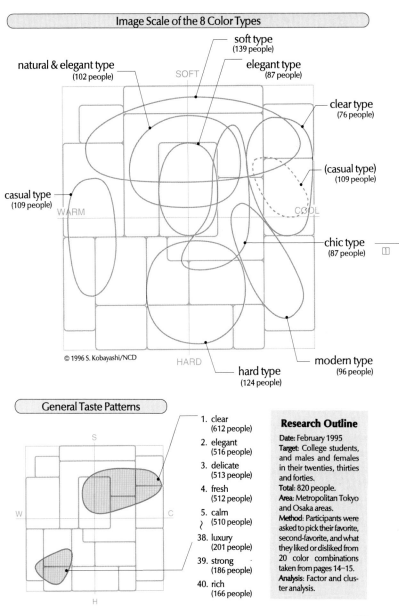

Image Scale of the 8 Color Types

soft type
(139 people)

natural & elegant type
(102 people)

elegant type
(87 people)

SOFT

clear type
(76 people)

(casual type)
(109 people)

casual type
(109 people)

WARM

COOL

chic type
(87 people)

© 1996 S. Kobayashi/NCD

HARD

hard type
(124 people)

modern type
(96 people)

General Taste Patterns

S

W

C

H

1. clear
(612 people)

2. elegant
(516 people)

3. delicate
(513 people)

4. fresh
(512 people)

5. calm
(510 people)

≀

38. luxury
(201 people)

39. strong
(186 people)

40. rich
(166 people)

Research Outline

Date: February 1995
Target: College students, and males and females in their twenties, thirties and forties.
Total: 820 people.
Area: Metropolitan Tokyo and Osaka areas.
Method: Participants were asked to pick their favorite, second-favorite, and what they liked or disliked from 20 color combinations taken from pages 14–15.
Analysis: Factor and cluster analysis.

Paris, France

Limoges, France

Selected Combinations

romantic

delicate

pretty

simple & tidy

→ Each star denotes about 10 people

1 ▷ Soft Type

62 males / 77 females = 139

students ★ ★ ★
20s ★ ★ ★ ★ ★
30s ★ ★ ★
40s ★ ★ ★

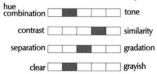

• Particular Tastes

Soft and grayish combinations were the most popular, with P, Vp, Lgr, white and light grays being the main colors.

• Color-Combination Techniques

hue combination	tone
contrast	similarity
separation	gradation
clear	grayish

• Profile

Favorite images: pretty, romantic, clear, natural, elegant.

Unselected images: gorgeous, classic, dandy, dynamic.

Design tastes: soft & curving, thin & slender, transparent, round, simple & tidy; pastels or watercolors; small patterns without strong contrast; light and flowing materials.

• Examples

• A delicate and meticulous blend with light grayish colors

• For tender and pretty small articles

• Small wildflower patterned fabrics

→ Refer to the diagram on page 129 and the scales on pages 145–53.

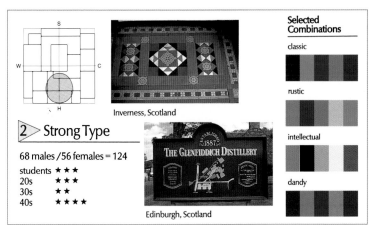

Inverness, Scotland

classic

rustic

intellectual

dandy

2 ▷ Strong Type

68 males / 56 females = 124

students ★ ★ ★
20s ★ ★ ★
30s ★ ★
40s ★ ★ ★ ★

Edinburgh, Scotland

• Particular Tastes

Dark tones and calm combinations preferred. Separation and contrast were attractive.

• Color-Combination Techniques

hue
combination ▭ tone

contrast ▭ similarity

separation ▭ gradation

clear ▭ grayish

• Profile

Favorite images: classic, dandy, chic, formal.

Unselected images: pretty, natural, casual, romantic.

Design tastes: strong, stable, traditional, tidy, unpatterned, thick; simple but not boring design; firm and solid materials, leather, stone.

• Examples

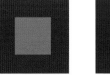

• Wool coats in classic styles

• Durable leather articles

• Creating sharp impressions with tone effects

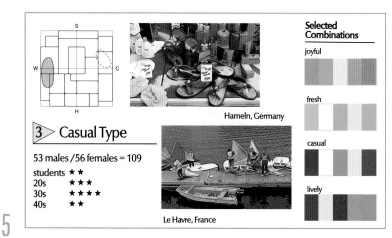

Hameln, Germany

Le Havre, France

Selected Combinations

joyful

fresh

casual

lively

3 ▷ Casual Type

53 males /56 females = 109

students ★ ★
20s ★ ★ ★
30s ★ ★ ★ ★
40s ★ ★

5

• Particular Tastes

Contrasts of vivid and bright tones were chosen; subjects preferred colors *with straight-forward and clear images; lively hue and color tastes.

• Color-Combination Techniques

hue combination �━━━━━━ tone
contrast ▬━━━━━━ similarity
separation ▬━━━━━━ gradation
clear ▬━━━━━━ grayish

• Profile

Favorite images: casual, cool-casual, dynamic, gorgeous.

Unselected images: chic, classic, dandy, natural.

Design tastes: easygoing items with a touch of playfulness; sportiness and movement, mixture of straight and curving lines, unique objects, handmade touches, glossy artificial plastic articles; a variety of color, material, shape and pattern combinations.

• Examples

• Use white as base color to offset vivid colors

• For youthful-looking sportswear

• Hue combinations are better for creating a resort atmosphere

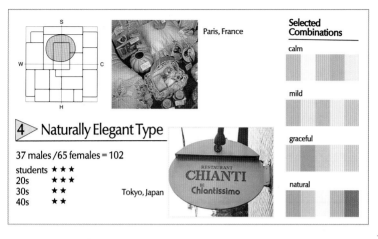

Paris, France

Selected Combinations

calm

mild

graceful

natural

4 ▷ Naturally Elegant Type

37 males /65 females = 102

students ★★★
20s ★★★
30s ★★
40s ★★

Tokyo, Japan

• Particular Tastes

They were impressed by sweet and calm R or RP combinations on a base of YR, Y or GY.

• Color-Combination Techniques

hue combination | ⬛ | tone
contrast | ⬛ | similarity
separation | ⬛ | gradation
clear | ⬛ | grayish

• Profile

Favorite images: natural, elegant.

Unselected images: gorgeous, classic, dandy, modern, dynamic.

Design tastes: mixture of mild & refreshing feelings, gentle & warm designs, round objects, comfortable to touch, natural fibers; avoidance of loud, cold & inorganic sense, and bold contrasts.

• Examples

• Similar color combinations create a relaxed environment

• Cotton as an everyday fabric

• For towels and cushions

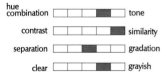

133

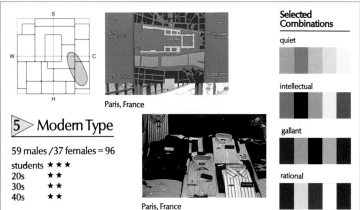

Selected Combinations

quiet

intellectual

gallant

rational

5 ▷ Modern Type

59 males /37 females = 96

students	★ ★ ★
20s	★ ★
30s	★ ★
40s	★ ★

Paris, France

• Particular Tastes

Attracted to achromatic and other cool colors, including separated combinations of black and white and combinations with contrast.

• Color-Combination Techniques

hue combination □□□□■ tone

contrast □■□□□ similarity

separation □■□□□ gradation

clear □□■□□ grayish

• Profile

Favorite images: modern, chic.

Unselected images: gorgeous, casual, dynamic, pretty.

Design tastes: rational, simple & hard designs; moderate gloss or subtle finishes like oxidized silver or frosted glasses; materials like metal, stone or glass; straight or geometric patterns; attracted more to shape or material than color.

• Examples

• Achromatic color combinations make the best use of materials and shape

• For a subtle, metallic feeling

• A modern feeling with tone contrast

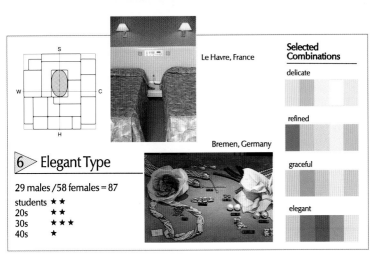

Le Havre, France

Bremen, Germany

Selected Combinations

delicate

refined

graceful

elegant

6 ▷ Elegant Type

29 males / 58 females = 87

students	★ ★
20s	★ ★
30s	★ ★ ★
40s	★

• Particular Tastes

Fond of grayish and calm colors of P, RP hue, with L and Lgr as the leading tone, including light gray.

• Color-Combination Techniques

hue combination	▬ tone
contrast	▬ similarity
separation	▬ gradation
clear	▬ grayish

• Profile

Favorite images: elegant, classic.

Unselected images: dandy, modern, casual, dynamic.

Design tastes: elegant & calm tastes, feminine touches, curving lines, a classic atmosphere with minimal decoration, delicate & high-quality items, smooth and moderate materials like silk or velvet.

• Examples

• Elegant coordination by use of similar hues

• Soft fabrics with feminine touch

• Create an elegant, feminine mood

135

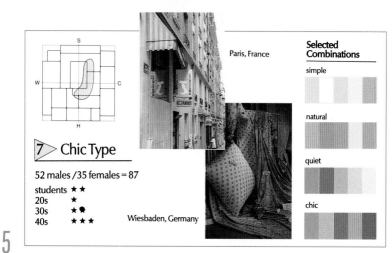

Paris, France

simple

natural

quiet

chic

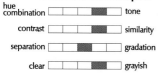

7 ▷ Chic Type

52 males / 35 females = 87

students ★ ★
20s ★
30s ★ ♠
40s ★ ★ ★

Wiesbaden, Germany

5

• Particular Tastes

The main choices were grayish combinations with Lgr tone and achromatic colors. They liked a refreshing and nonchalant tone feeling.

• Color-Combination Techniques

hue
combination ▭▭▭▭▭ tone

contrast ▭▭▭▭▭ similarity

separation ▭▭▭▭▭ gradation

clear ▭▭▭▭▭ grayish

• Profile

Favorite images: chic, natural.

Unselected images: casual, dynamic, gorgeous, wild, modern.

Design tastes: relatively plain colors; tactility & materiality such as found in stone, Japanese paper or bamboo; quiet atmosphere; non-figurative style; slightly subdued feeling; simple design; a bit of a sheen; avoidance of both overly artificial sharpness and a sporty feel.

• Examples

• A natural feel with a sense of calm

• A grayish, subtle tone sense creates a feel of sophistication

• Solid with intelligence and moderateness

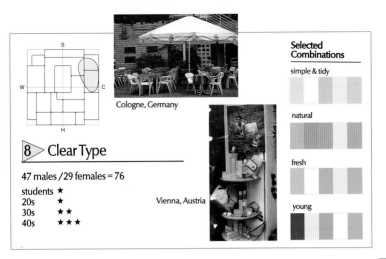

Cologne, Germany

simple & tidy

natural

fresh

young

Vienna, Austria

8 ▷ Clear Type

47 males / 29 females = 76

students ★
20s ★
30s ★ ★
40s ★ ★ ★

• Particular Tastes

Clear-cut color combinations without muddiness. Preferred base tones were white or cool colors. Warm colors could be used as accent colors.

• Color-Combination Techniques

hue
combination [] tone

contrast [] similarity

separation [] gradation

clear [] grayish

• Profile

Favorite images: clear, cool-casual, casual.

Unselected images: classic, gorgeous, chic.

Design tastes: soft & clear colors adding a youthful or joyous feel to the basic image; artificial materials; this simple style avoids one-of-a-kind and overly unique articles, or a too-precious and elaborate atmosphere.

• Examples

• Clean and neat summer clothes

• For rejuvenation, uplifting and healthy feeling

• For clear color images to match plastic's transparency

▼ Personal and Work Environments:
A Sample Study

Settings, roles and events in daily life become more visible and realistic when our feelings about them are expressed through colors and images. Both personal and business elements crop up in most basic situations, and are perceived differently depending on how people live, who is viewing them, and what each person's personal preferences happen to be. Image research helps us understand the subliminal similarities.

We questioned a small group of postgraduate architecture students about their impressions of family, business and school. The results are shown visually on the image scale to the right. Notable patterns include the following:

1. Images of family range from the WC axis to the center of the calm colors.
2. Images of business extend from rational CH feelings to energetic WH feelings.
3. Images of school are cheerful and associated with clear colors.

▼ Additional Observations*

• The mother image once dominated the image of the family, while the business image was the realm of the father. However, changing social conditions have resulted in a blending of images that in earlier times had been discrete. As women and mothers entered the work force, images of business seeped into family life, changing the nature of both settings dramatically.** When researching color for either setting, use the database and image scale to understand the situation. Keep in mind that images are in flux, and consider future trends.

• When using a setting's general images as a base, colors should be coordinated according to tastes or an ideal vision. Remember that trends may dominate, or may be limited to, a particular period or age group.

• Take into account the subject's position: for example, students (who have yet to enter the workforce) view business settings with a narrower and more fixed frame of reference.

*Based on other research and the study introduced on page 125.

** → page 140

Image Research of Family and Business Settings*

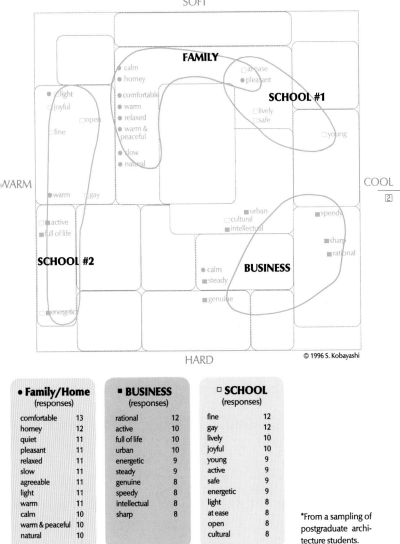

SOFT

FAMILY

SCHOOL #1

- light
- joyful
- open
- fine
- calm
- homey
- comfortable
- warm
- relaxed
- warm & peaceful
- slow
- natural
- at ease
- pleasant
- lively
- safe
- young

WARM

COOL

- warm
- gay
- active
- full of life

SCHOOL #2

- urban
- cultural
- intellectual
- speedy
- sharp
- rational
- calm
- steady

BUSINESS

- genuine
- energetic

HARD

© 1996 S. Kobayashi

• Family/Home (responses)	
comfortable	13
homey	12
quiet	11
pleasant	11
relaxed	11
slow	11
agreeable	11
light	11
warm	11
calm	10
warm & peaceful	10
natural	10

■ BUSINESS (responses)	
rational	12
active	10
full of life	10
urban	10
energetic	9
steady	9
genuine	8
speedy	8
intellectual	8
sharp	8

□ SCHOOL (responses)	
fine	12
gay	12
lively	10
joyful	10
young	9
active	9
safe	9
energetic	9
light	8
at ease	8
open	8
cultural	8

*From a sampling of postgraduate architecture students.

The onward march of technology, instant foods and other conveniences of the modern world effect everyday life, and their images make an impression on the WS-type family setting.

Conversely, the idea of a more informal and relaxed office atmosphere is taking hold in many companies, which in turn has influenced the staunch CH image of the business setting.

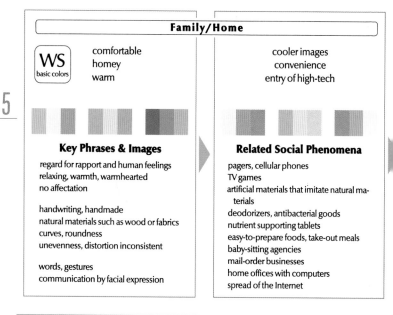

Family/Home

WS basic colors

comfortable
homey
warm

cooler images
convenience
entry of high-tech

Key Phrases & Images

regard for rapport and human feelings
relaxing, warmth, warmhearted
no affectation

handwriting, handmade
natural materials such as wood or fabrics
curves, roundness
unevenness, distortion inconsistent

words, gestures
communication by facial expression

Related Social Phenomena

pagers, cellular phones
TV games
artificial materials that imitate natural materials
deodorizers, antibacterial goods
nutrient supporting tablets
easy-to-prepare foods, take-out meals
baby-sitting agencies
mail-order businesses
home offices with computers
spread of the Internet

Color and Image Making

Mother Image

Father Image

© 1996 S. Kobayashi PAT.1106334 NCD INST.

Yet, if we were to bring office equipment into the living room, the mechanical and cool images would be overpowering; if home-style furnishings were placed in a business office, they would undermine the sense of efficiency and reliability the setting requires.

When basic colors and images are ignored, the result can be disastrous since the appearance will not suit the needs of the setting. Once you know the basic color (or colors) of a space, you should design an image that blends comfort and function according to the needs of the client and setting.

Business

becoming more natural
relaxing
becoming more personal

rational
minute
reasonable

CH
basic colors

Related Social Phenomena

refreshing space; atrium and open space
rental plants
comfortable office furniture
employee's lounge
greater flex-time
more female employees

Key Phrases & Images

priority of function and efficiency
systematic, well regulated
digital sense, mechanical
simple, cool, smart, formal

printed type
artificial materials such as metal
processed goods
straight, smooth, organized

multimedia, email, computers

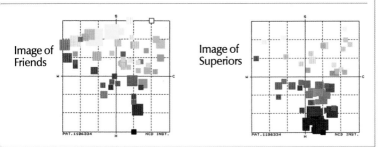

Analysis of research presented on pages 125–26. Compare with the data gathered on family and business settings in this chapter.

Image of Friends

Image of Superiors

Home and Office
A Businessperson's Perspective

A colorist needs to be aware of comparative studies. Below are the results of our research on perceived images of family and business among company employees. Words that were not chosen by students (pages 138–39) surfaced in this study, including "light,", "safe," "clean" and "agreeable."

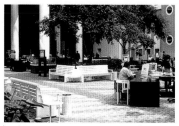

The plaza of the Dresden Bank in Dusseldorf, Germany, is a comfortable business space.

Data: Collected from architects between twenty and fifty who participated in our seminars and lectures.
Research date: October 1994 to February 1995. Participants: 44 males, 63 females; living in the Tokyo area.

5

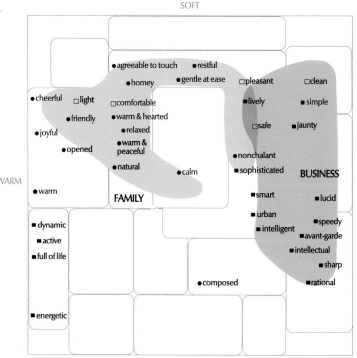

© 1996 S. Kobayashi/NCD

LEGENDS: ● Family, ■ Business, □ Selected for both

Colorists need to be able to prioritize when choosing images for color planning. Organizing samples and taking into consideration the client's needs and vision from the outset are the best ways to accomplish this. After you pinpoint specific images, you'll know which color technique to employ. One sample analysis of a business setting (a department store) and two concrete examples of sampling images and organizing them on the images scale follows. But before you begin, here are a few pointers on professional conduct.

Business Sense for Colorists—A Check List

▼ 1. Keep a broad perspective
Since color enters into all fields, colorists need to be open-minded and observe developments in business, academic, creative and other fields.

▼ 2. Use data, not personal preferences
Colorists should not force their personal tastes on their clients; a colorist is not an artist. Clients can be convinced through various data.

▼ 3. Accurate sampling
Colorists can get a general view of color images by collecting photographic images and then comparing them closely.

▼ 4. Keys for inspiration from everyday life
Colorists should be aware of the possibility of creating realistic scenes using feelings and data taken from daily life.

▼ 5. Image and concept
When selecting color images, the colorist should take into account both present and future trends.

▼ 6. Communication
Colorists frequently work with experts in other fields, and it is important to listen to their opinions.

▼ 7. Costs and risks
It is important to take into consideration the life span of a particular color to avoid unnecessary expense. Colors, like fashion accessories, can date.

▼ 8. Don't rely exclusively on color samples
Colorists should know how to use color samples, taking into account shades of color, lighting and materials.

▼ 9. Fashion knowledge
After mastering the basic method of coordinating colors, a colorist can apply his knowledge not only to patterns, designs and materials, but also to hairstyles, make-up, trends and TPO (time, place and occasion).

▼ 10. Desire to improve
Colorists should consider the essence of images and techniques. When you see something interesting, think about the images and color techniques that were used to create it. Record the image and your thoughts.

Big-city department stores have sections promoting high-quality, everyday goods. Stores are organized to attract consumers, and it is useful to study their colors and images, observing seasonal sections and offerings.

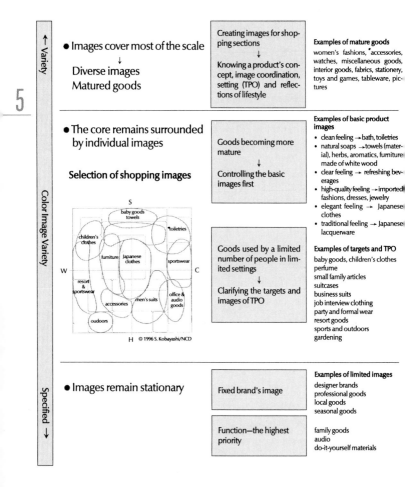

← Variety

Color Image Variety

Specified →

- Images cover most of the scale

 ↓

 Diverse images
 Matured goods

Creating images for shopping sections

↓

Knowing a product's concept, image coordination, setting (TPO) and reflections of lifestyle

Examples of mature goods
women's fashions, accessories, watches, miscellaneous goods, interior goods, fabrics, stationery, toys and games, tableware, pictures

- The core remains surrounded by individual images

Selection of shopping images

Goods becoming more mature

↓

Controlling the basic images first

Examples of basic product images
- clean feeling → bath, toiletries
- natural soaps → towels (material), herbs, aromatics, furniture made of white wood
- clear feeling → refreshing beverages
- high-quality feeling → imported fashions, dresses, jewelry
- elegant feeling → Japanese clothes
- traditional feeling → Japanese lacquerware

S

baby goods
towels

toiletries

children's clothes

furniture | Japanese clothes | sportswear

W | | C

resort & sportswear

accessories | men's suits | office & audio goods

oudoors

H © 1996 S. Kobayashi/NCD

Goods used by a limited number of people in limited settings

↓

Clarifying the targets and images of TPO

Examples of targets and TPO
baby goods, children's clothes
perfume
small family articles
suitcases
business suits
job interview clothing
party and formal wear
resort goods
sports and outdoors
gardening

- Images remain stationary

Fixed brand's image

Examples of limited images
designer brands
professional goods
local goods
seasonal goods

Function—the highest priority

family goods
audio
do-it-yourself materials

5

Area images vary from place to place, whether we are observing different countries, different cities within the same country, or even districts within the same city. Newly developed and redeveloped shopping and entertainment areas are continuously making themselves over, reflecting new trends to attract more consumers. Displays, signs, design and atmosphere differ depending on the area's image—and help define its identity.

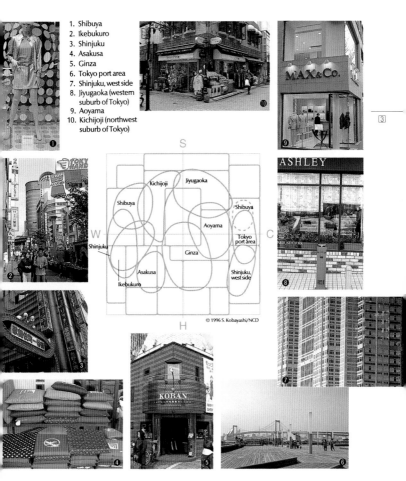

1. Shibuya
2. Ikebukuro
3. Shinjuku
4. Asakusa
5. Ginza
6. Tokyo port area
7. Shinjuku, west side
8. Jiyugaoka (western suburb of Tokyo)
9. Aoyama
10. Kichijoji (northwest suburb of Tokyo)

© 1996 S. Kobayashi/NCD

145

■ CHECK POINT ■

Signs and Logos

Signs, billboards and other commercial displays supply clues to the color preferences of an area, business or clientele. Look carefully at billboards, shop signs and logos. How are their basic color images and other design elements connected? Do the signs match the local lifestyle? What image or images on the word image scale do they project?

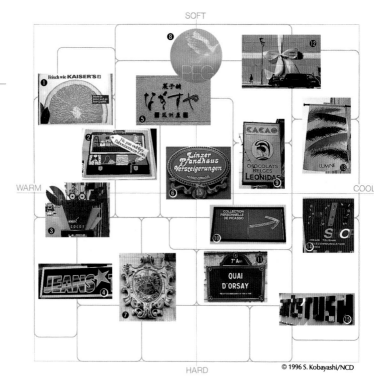

© 1996 S. Kobayashi/NCD

1. Hameln, Germany
2. Amiens, France
3. Asahikawa, Japan
4. Cologne, Germany
5. Fukuoka, Japan
6. Linz, Austria
7. London, England
8. Limoges, France
9. Amiens, France
10. Paris, France
11. Paris, France
12. Ginza, Tokyo, Japan
13. Shinjuku, Tokyo, Japan
14. Omote-sando, Tokyo, Japan
15. Shibuya, Tokyo, Japan

→ WS = joy, vitality, familiarity
WH = strength, gorgeousness, tradition
CS = exhilaration, freshness, clearness
CH = modernity, precision, reliability
Center = calmness, elegance, chic

→ pages 24–25, 151, 153

Color Image Change within the Image Scale

We used white, black and red as main colors (and gray as a secondary color) to study image change by quadrants on the image scale. The following patterns emerged:

1. The color combinations with white, black or red as a major element are, for the most part, distributed around the circumference of the scale.

2. The proportion of white to red, red to black, and white to black shifts gradually as you move horizontally or vertically through a quadrant.

3. The 2-color combinations of white and gray, black and gray, and red and gray are clustered along the WC/SH axes and gravitate toward the center.

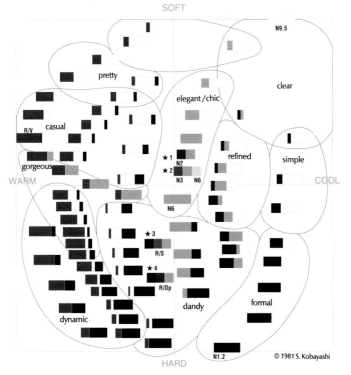

→ Starred examples 1 to 4 indicate combinations that use colors outside the four basic colors of red, white, black and gray. They have been included as transitional links.

147

■ CHECK POINT ■
Interior Color Images

1. Family Setting
Research your own and your client's family setting to find a common home image. → pages 138–42

2. Taking General Images as a Basis
Discern and check the uniqueness of your client's family life.

3. Color and Image Planning
Place the images of each room on the scale. Does the family's common space fall on the calm color zone in the center of the scale or elsewhere? Note the general overall preferences and specific taste requirements of more private areas, including the study, hobby room, and sleeping quarters.

● Interior Designs and Color Types

Let's look at different interior design and material preferences using 2 of the 8 types introduced on pages 130–37 as examples.

Soft Types → This type of person is fond of slender, steamlined forms and materials that are lightweight, agreeable to the touch and smooth.

Hard Types → This type of person likes solid and stable shapes, and cool and artificial, and/or heavy materials.

In addition, Soft Types are attracted to thin cotton or natural and soft curtains, and Hard Types prefer heavier fabrics, such as tweed.

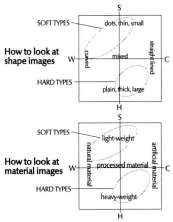

● Colors Frequently Used for Interiors

→ Taken from research conducted in 1981–95 on curtains, wallpaper, carpets and wood.

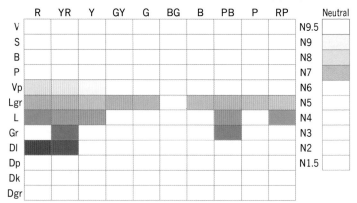

4. Choosing Colors and Materials

Collect samples of various interior materials and arrange them from "soft" to "hard," with an eye toward how to bring out the tonal feelings you observe. Are the colors well-linked to other colors?

5. Coordinating Room and Furniture/Equipment

If a tone preference is distinguishable from the colors of the ceiling, walls, floors and doors, you can easily coordinate additions with these basic colors. If the furniture and/or equipment hues are linked by a tone sense, you could change floor, walls, and ceilings accordingly.

● Image Scale for Interior Designs

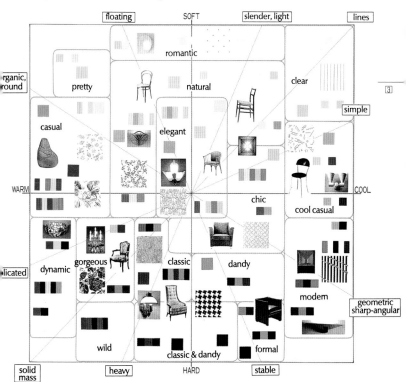

Note: When the images were plotted on the scale, shapes were initially set along the SH axis. Small, thin and light objects were then shifted in toward "soft" while their opposites were moved toward "hard." Thus, to evaluate the results, it is important to note the relationship of the image/shape to the SH axis. Next, compare the difference of each shape with its position on the WC axis. You can also use the dotted-line subaxes to gauge a shape's nuance. Last, notice how shapes with a mixture of straight and curved lines and/or a combination of natural and artificial materials gravitate toward the center of the scale.

Food Images

1. Image of Tastes

We arranged everyday foods on the image scale according to look and taste. Sweets fell on WS, salty and spicy foods on WH, refreshing foods on CS, bitter foods on CH and mild foods in the center. Plain tastes were soft, and rich thick tastes were hard.

● Flavor Images

In a restaurant or the home of a gifted cook, the selection of food depends almost entirely on the chef's aesthetic sense. Color as well as flavor play a role in the overall enjoyment of a meal. In certain instances, even the dining table provides inspiration for the colorist. You could study the color linkage from the standpoint of color image, checking whether it is based on hue combination or tone combination and, say, separation or gradation. Time of day and season are other variables to consider.

© 1996 S. Kobayashi/NCD

● Food Image and Color

Flavor	Foods	Color Combinations		Related Words
sweet	cake chocolate candy	bright, soft combinations, often with red and pink as basic tone.		pretty childish springlike
sour	citrus pickled plum vinegar	clean combinations with light yellow and green as main colors		fresh healthy pure
flavorful	matsutake mushroom clear soup dried cuttlefish	tone combinations with calm beige		warm tranquil easygoing
spicy	curry red chili pepper tacos	yellow as in mustard and curry, and red chili		hot active bold
salty	salted cuttlefish salted salmon pickles	light grayish combinations as in salted foods		dry
bitter	black coffee fish liver Chinese medicine	hard and plain color tones; opposite of sweet		dandy serious adult
astringent	green tea powdered tea bitter persimmons	grayish color tones often based on Japanese traditional aesthetic		picturesque rustic old fashioned

2. Food Image and Packaging

Food packaging is constantly changing. However, packages that represent a distinctive image in terms of taste and vision are memorable and long-lasing. A number of such packages appear below.

Though CH packages were once considered unsuitable for food, we can now find streamlined and mechanical images on the scale. At the center is an elegant and natural zone that increases as a culture matures.

● Image Scale for Food Packaging *

Patent: NCD

* Food package sampling from 1986.

■ CHECK POINT ■
Fashion Image

1. Expressing Individuality & Creating Self-Identity

Individual color preferences often emerge upon inspection of the wardrobe and living space. Let's look at the colors of your clothing and home and locate them on the scale. These colors should reveal your self-identity. Compare your results here with the results of the single-color and color-combination exercises you did in Chapter 1. Some images will coincide, but others may not. However, the colors of your living quarters and clothing can still offer valuable insights into your preferences and lifestyle.

● Textile Pattern Images

1. Patterns have been divided roughly. Toward the W direction are traditional and figurative patterns of flowers, each with a sense of joy, comfort and flamboyance. Towards the C direction are geometrical and abstract patterns.
2. Generally, detailed patterns gravitate around the center, and larger patterns around the edges.
3. S attracts sparse, scattered patterns; dense patterns congregated around H.
4. Repetitive patterns (such as those with small flowers), delicate patterns, and plainer woven patterns collect in the center.

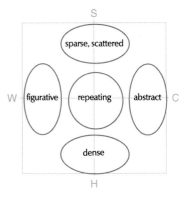

● Color Images for Women's Sweaters (1981–95)

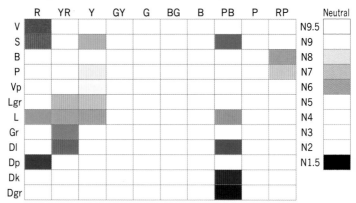

	R	YR	Y	GY	G	BG	B	PB	P	RP	Neutral
V											N9.5
S											N9
B											N8
P											N7
Vp											N6
Lgr											N5
L											N4
Gr											N3
Dl											N2
Dp											N1.5
Dk											
Dgr											

2. Your Lifestyle

Fabric, design, silhouette and TPO are as important in fashion as color. Hair color and style, facial shape, skin color, make-up and accessories also play a part. Choose your favorite patterns on the scale below to determine your own image. Consider which clothing style you normally adopt—coordinated or distinct colors? Then choose 2 favorites from the 8 lifestyle color types discussed on pages 130–37. The key to fashion is finding your own identity and individual way of expression.

● Image Scale for Clothing Patterns

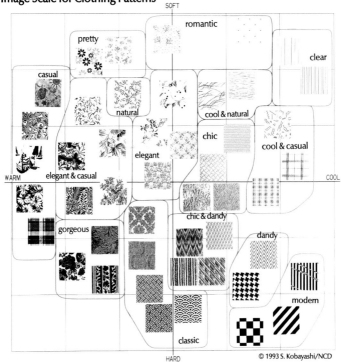

SOFT

romantic

pretty

clear

casual

natural

cool & natural

chic

cool & casual

elegant

WARM elegant & casual COOL

chic & dandy

gorgeous

dandy

modern

classic

HARD

© 1993 S. Kobayashi/NCD

The Relationship between Pattern and Color

Even when patterns are similar, the images look different depending on the use of color.

1. Generally, when the strengths of the pattern and the color vary to a large degree, the total image is controlled by the stronger element.

2. The simple stripe patterns in the CS quadrant are strongly influenced by the color image used.

3. Conversely, the gorgeous patterns in the WH quadrant are more impressive than the colors themselves.

Hue and Tone System—130 Color Names* (For color samples, see pages 8-

	tone/hue	R	YR	Y	GY	G
vivid	V vivid tone	1 Carmine	2 Orange	3 Yellow	4 Yellow Green	5 Green
	S strong tone	11 Rouge Coral	12 Persimmon	13 Gold	14 Grass Green	15 Malac Green
bright	B bright tone	21 Rose	22 Apricot	23 Canary Yellow	24 Canary	25 Emera
	P pale tone	31 Flamingo	32 Sunset	33 Sulphur	34 Lettuce Green	35 Opali Green
	Vp very pale tone	41 Baby Pink	42 Pale Ochre	43 Ivory	44 Pale Chartreuse	45 Pale C
subdued	Lgr light grayish tone	51 Pink Beige	52 French Beige	53 Light Olive Gray	54 Mist Green	55 Ash G
	L light tone	61 Sandalwood	62 Beige	63 Mustard	64 Pea Green	65 Spray
	Gr grayish tone	71 Rose Gray	72 Rose Beige	73 Sand Beige	74 Mistletoe Green	75 Mist
	Dl dull tone	81 Old Rose	82 Camel	83 Dusty Olive	84 Leaf Green	85 Jade
dark	Dp deep tone	91 Brick Red	92 Brown	93 Khaki	94 Olive Green	95 Viridia
	Dk dark tone	101 Mahogany	102 Coffee Brown	103 Olive	104 Ivy Green	105 Bottle
	Dgr dark grayish tone	111 Maroon	112 Falcon	113 Olive Brown	114 Seaweed	115 Jungle

* Color names should not be considered final nor limited to the single shade presented here, since each of the 130 colors has its own wider range.

BG	B	PB	P	RP	Neutral	
6 Peacock Green	7 Cerulean Blue	8 Ultra-marine	9 Purple	10 Magenta	121 N9.5	White
16 Jewel Green	17 Light Blue	18 Sapphire	19 Violet	20 Spinner Red	122 N9	Pearl Gray
26 Turquoise	27 Sky Blue	28 Salvia Blue	29 Lavender	30 Rose Pink	123 N8	Silver Gray
36 Light Aqua Green	37 Aqua Blue	38 Sky Mist	39 Lilac	40 Mauve Pink	124 N7	Silver Gray
46 Horizon Blue	47 Pale Blue	48 Pale Mist	49 Pale Lilac	50 Cherry Rose	125 N6	Medium Gray
56 Eggshell Blue	57 Powder Blue	58 Moon-stone Blue	59 Starlight Blue	60 Rose Mist	126 N5	Medium Gray
66 Venice Green	67 Aqua-marine	68 Pale Blue	69 Lilac	70 Orchid	127 N4	Smoke Gray
76 Blue Spruce	77 Blue Gray	78 Slate Blue	79 Pigeon	80 Orchid Gray	128 N3	Smoke Gray
86 Cambridge Blue	87 Shadow Blue	88 Shadow Blue	89 Dusty Lilac	90 Old Mauve	129 N2	Charcoal Gray
96 Prussian Green	97 Peacock Blue	98 Mineral Blue	99 Pansy	100 Wine	130 N1.5	Black
106 Teal Green	107 Teal	108 Dark Mineral Blue	109 Prune	110 Red Grape		
116 Dusky Green	117 Prussian Blue	118 Midnight Blue	119 Dusky Violet	120 Taupe Brown		

Fashion Image Scale

(See **Exercise 4** on pages 16–17)

The positions of the 3-color combinations introduced on page 17 are shown at the right, and a revised scale with key fashion words is presented below.

● Key Fashion Image Words

1. pretty
2. romantic
3. clean
4. warm & cordial
5. tranquil
6. delicate
7. womanly & slender
8. natural
9. jaunty
10. showy
11. colorful
12. simple & appealing
13. lovely
14. fashionable
15. chic
16. cool casual
17. youthful
18. gorgeous
19. old-fashioned
20. cerebral
21. sporty
22. wild
23. placid
24. earnest
25. modern

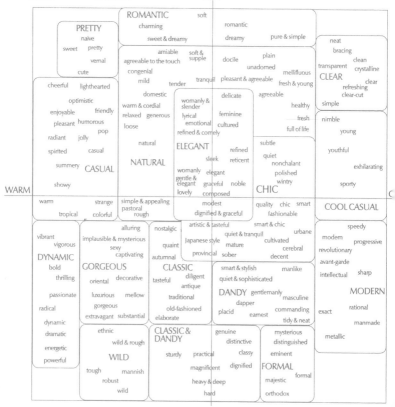

Interior Image Scale

(See **Exercise 5** on pages 18–19)

The diagram to the right roughly indicates the location of the chairs used for Exercise 5. For interior image research, you can use the 180-word scale below, which is adopted from the basic image scale on pages 10–11.

SOFT

ROMANTIC — slight — light & pale

PRETTY
naive
pretty
childlike
cute

charming
sweet & dreamy — romantic
dreamy — pure & simple

neat
bracing
transparent — clean

NATURAL — amiable
agreeable to the touch
congenial — tranquil
mild — tender
domestic
happy-go-lucky
cozy & comfortable
warm & cordial
comfortable & laid-back
generous
temperate & mild
spacious
high-touch
natural

plain — light
unadorned
peaceful — mellifluous
unconstrained — fresh & young
elaborate & delicate
agreeable
delicate
feminine
womanly & slender
emotional — cultured
refined & comely — refined
dewy
sleek — elegant
graceful
composed

fresh
full of life
steady
subtle
careful — quiet
nonchalant
polished
simple & frugal

CLEAR — crystalline
clear
refreshing
sensitive — clear-cut
simple

jaunty
young
youthful
explicit
exhilarating
cold
sporty

cheerful — lighthearted
bright — carefree
enjoyable — friendly
humorous — open
spirited — casual
CASUAL
showy

ELEGANT
womanly
gentle & elegant
lovely

modest
dignified & graceful
CHIC. chic smart
fashionable
fantastic

Western style
COOL CASUAL
speedy

M ———

COOL

warm — flamboyant
tropical — colorful
vibrant
vigorous
active
bold
passionate
fiery
dynamic
dramatic
energetic
DYNAMIC

simple & appealing
pastoral
rough
attractive
alluring
sexy
captivating
GORGEOUS
decorative
luxurious — mellow
gorgeous
extravagant — substantial
ethnic
WILD
tough — mannish
robust
wild

grand
artistic & tasteful
quaint — Japanese style — quiet & tranquil
cultivated
provincial — sober — cerebral — composed
CLASSIC
tasteful — diligent — quiet and sophisticated
complicated — antique — DANDY
traditional — dapper — gentlemanly — manly
old-fashioned — placid — masculine
elaborate — reliable — earnest — tidy & neat
CLASSIC & DANDY — genuine — mysterious
distictive — distinguished
sturdy — eminent
heavy & deep — dignified — formal
strong & robust — majestic — austere
FORMAL

urbane
modern — progressive
revolutionary — alert
intellectual — advanced
sharp
MODERN
exact — rational
organized — manmade
high-tech
metallic

COOL

© 1996 S. Kobayashi/NCD

HARD

■ **Major European Sites Visited for Research**

HUNGARY

●Vienna
den
;raz
Pecs ●

● Budapest
● Kecskemet

Acknowledgments

The staff of Nippon Color & Design Research Institute was of great help in analyzing data on human feelings. I would also like to extend my gratitude to a number of other people whose work on the present volume proved invaluable: Keiichi Ogata and Leza Lowitz for the translation; Tetsuo Kuramochi and Barry Lancet of Kodansha International for their editorial work; Junichiro Matsuoka of Kodansha; the staff of Toppan Printing; Jeanmarie McNiff for her copyediting and proofreading; Katsura Iwamatsu and Tsuguhito Fukuosa for editorial assistance; the Tokyo University Botanical Garden, Yoshiyori Michie, Shouichi Sato, Akiko Sugiyama, Akihiko Suzuki, Setsuko Horiguchi, Machiko Tamura, Mami Takizawa, Yasunari Nishimura, Keiko Yoshida, Tomoko Suzuki, and Hideharu Oishi for their cooperation and support; and Tokyo National Museum and Ota Memorial Museum of Art for permission to reproduce photographic material.

Shigenobu Kobayashi graduated from Hiroshima College of Technology and received his master's degree from Waseda University for his work in the field of color psychology. In 1966, he founded the Nippon Color & Design Research Institute (NCD) and has since become a leader in the field of color psychology. Kobayashi is the author of over 30 books on color in the Japanese language, with total sales in excess of 400,000 copies. *Colorist* is his third English-language publication, following *A Book of Colors* (1987) and *Color Image Scale* (1991). Kobayashi is also an active participant of the International Color Association (AIC) and a lecturer at the graduate school of the Musashi Institute of Technology.

The Nippon Color & Design Research Institute (NCD) acts as a color and design consultant firm to over 300 major Japanese corporations in fields as diverse as automobiles, home appliances, cosmetics, food, department stores, and home construction. Along with its theories on the psychology of color, the institute's Color Image Scale has been applied to numerous projects, and software based on the image scale has been developed.

Address
Dai 2 Tanaka Bldg, 5–2 Hongo 3-chome, Bunkyo-ku, Tokyo,
Japan 113–0033
e-mail: sic@mars.dti.ne.jp